AMERICAN
LANDSCAPES

AMERICAN LANDSCAPES

TREASURES FROM THE PARRISH ART MUSEUM

ALICIA G. LONGWELL

PARRISH ART MUSEUM, Southampton, N.Y.
in association with D Giles Limited, London

Published in conjunction with the exhibition
American Landscapes: Treasures from the Parrish Art Museum
September 27–November 29, 2009
Parrish Art Museum
25 Jobs Lane
Southampton, N.Y. 11968
parrishart.org

The publication and exhibition are made possible through a generous grant from the Henry Luce Foundation with additional support provided by the Peter Jay Sharp Foundation, Lynne and Richard Pasculano, Liliane and Norman Peck, Herman Goldman Foundation, and Allison Morrow.

Research for this project was generously funded through The Werner and Maren Otto Endowment Fund for the Study of the Art and Artists of Eastern Long Island.

First published in 2010 by GILES, an imprint of D Giles Limited, in association with the Parrish Art Museum.

D Giles Limited, London
4 Crescent Stables,
139 Upper Richmond Road,
London, SW15 2TN, UK
www.gilesltd.com

ISBN: 978-0-943526-53-9 (softcover)
ISBN: 978-1-904832-74-4 (hardcover)

Library of Congress Cataloging-in-Publication Data

Parrish Art Museum.
American landscapes : treasures from the Parrish Art Museum / Alicia G. Longwell. – 1st ed.
p. cm.
Published in conjunction with an exhibition held at the Parrish Art Museum, Sept. 27-Nov. 29, 2009.
Includes bibliographical references.
ISBN 978-1-904832-74-4 (hardcover) – ISBN 978-0-943526-53-9 (softcover)
1. Landscape painting, American--Exhibitions. 2. Landscape painting–New York (State)–Southampton–Exhibitions. 3. Parrish Art Museum–Exhibitions. I. Longwell, Alicia Grant. II. Title. III. Title: Treasures from the Parrish Art Museum.
ND1351.P37 2010
158'.17307474725--dc22
2010000426

For Parrish Art Museum:
Director: Terrie Sultan
Curator: Alicia G. Longwell
Managing Editor: Alicia G. Longwell

For D Giles Limited:
Copy-edited and proof-read by Melissa Larner
Designed by Miscano Design, London
Produced by GILES, an imprint of D Giles Limited, London
Printed and bound in Hong Kong

All measurements are in inches;
Height precedes width.

Front cover illustration:
Sheridan Lord (American, 1926–1994)
Landscape, Autumn 1974 (large detail), 1974
Oil on canvas, 40 × 70 inches

Back cover illustration (softcover only):
William Stanley Haseltine (American, 1835–1900)
Anacapri, 1892
Oil on canvas, 22 ¾ × 36 ⅜ inches

CONTENTS

6
Introduction and Acknowledgments
Terrie Sultan

9
American Landscape Painting: In the Eye of the Beholder
Alicia G. Longwell

19
Plates

102
Selected Bibliography

103
Photography Credits

104
Index

INTRODUCTION AND ACKNOWLEDGMENTS

The first in a series of books exploring the breadth and depth of the Parrish Art Museum's permanent collection, *American Landscapes* sets the stage for the captivating story of the burgeoning impulses that helped shape a truly American school of art. It is a journey that begins with early visitors to the East End of Long Island, such as Samuel Colman and Edward Lamson Henry, and gathers steam in the late nineteenth century, as the East End of Long Island came to prominence with the advent of improved railroad connections from New York City to the eastern edge of Long Island. Attracted by the light and the relaxed atmosphere, artists began to come more often, stay for longer periods of time, and even set up ateliers and schools on both the North and South Forks of Long Island. Thomas Moran began spending summers in East Hampton between 1879 and 1922, painting numerous locales in East Hampton and Montauk. William Merritt Chase founded the Shinnecock Hills Summer School in 1891, attracting many artists who sought to capture the landscape *en plein air* through the beauty of oil paint. Throughout the early 1900s, 1920s and 1930s, artists such as Guy Pène du Bois and Robert Henri visted, painted, and taught here, and later, during a particularly fertile period of creativity before and after World War II, many artists associated with the Surrealists, such as Max Ernst, flocked to the area. Jackson Pollock moved permanently to Springs in 1945, and along with Lee Krasner, Willem de Kooning, Roy Lichtenstein and many others, solidified the East End as a vibrant, livable, and productive artistic community. Their success has encouraged many internationally renowned and younger, emerging artists to live and work here. Each has an individual story to tell that, contextualized by the strengths of the permanent collection, creates an aggregate, non-linear narrative that is both intellectually coherent and visually compelling.

The Parrish Art Museum is uniquely placed within one of the most concentrated creative communities in the United States. It is not surprising that Samuel Longstreth Parrish should have found his intellectual voice here. Parrish was, by interest and education, an aficionado of Italian painting. Born to an old Quaker family in Philadelphia and educated at Harvard, he established a law practice in New York City and summered often with his mother in her Southampton cottage. By 1891 he had become a patron of Chase's Shinnecock school, commissioning Chase to paint a portrait of his mother, Sarah Redwood Parrish, the following year. By 1896 Parrish had decided to open a museum in Southampton for the display and interpretation of his growing collection of Italian paintings and casts of classical sculpture. Designed by distinguished architect Grosvenor Atterbury, The Art Museum at Southampton opened to the public in 1898.

Although Parrish was an early supporter of Chase, he did not collect American art. It took more than fifty years for the museum, through the guidance of Southampton resident and art collector Rebecca Bolling Littlejohn, to reorganize itself after Parrish's death and to begin to collect, present, and interpret works by American painters. Elected

President of the Board of the Museum in 1952, Littlejohn transformed the Parrish into a museum in the modern model, completing the Parrish's development from a repository for one man's vision into a broad-based center for cultural engagement focused specifically on the remarkable region in which it exists. Under Mrs. Littlejohn, the Museum began actively to acquire American art by artists who worked in the area, and upon her death she bequeathed more than 300 paintings that form the solid backbone of the Parrish Art Museum. Landscape painting is the heart of the permanent collection, reflecting both the Museum's physical location and its long and vital relationship to the history of American art. *American Landscapes: Treasures from the Parrish Art Museum* brings together forty-two images of masterworks from the Museum's collection, beginning with early nineteenth-century natural views such as Thomas Birch's *Fishing Boats*, ca. 1820, and Asher B. Durand's *Landscape*, ca. 1844. Masterwork *plein-air* paintings by William Merritt Chase, such as *Shinnecock Landscape*, ca. 1894, and twentieth-century works by John Marin, Charles Burchfield, as well as Fairfield Porter's *Backyard, Southampton*, 1953, reflect landscape's expanded modernist vocabulary. The compendium culminates with two monumentally scaled vistas by area residents dedicated to recording the evanescent nature of Long Island's ever-changing skies and waters: April Gornik's *Light Before Heat*, 1983, and Jane Wilson's *The Wave*, 1988. Rooted in history but dedicated to the present and future tenses of art, the Parrish Art Museum celebrates the unique artistic legacy of Long Island's East End and its influence throughout the world and grounds its mission in this unique and creatively unparalleled community, honoring and celebrating the global influence exerted by the artists nurtured here. Many individuals have made possible this important volume. Alicia Longwell, Lewis B. and Dorothy Cullman Chief Curator, Art and Education, distinguished herself in writing an illuminating essay and outstanding entries on the treasures in the Parrish's permanent collection. Registrar Chris McNamara and Curatorial Assistant Sam Bridger Carroll took responsibility for overseeing the myriad details pertaining to photography, captions and overall management of the manuscript preparation. At D Giles Limited, London, we are grateful for Miscano Design's elegant creative approach; Melissa Larner for precise copyediting; Allison Giles and Sarah McLaughlin for administration, and of course to Dan Giles himself for guiding us through every stage of the project.

We are deeply indebted to the Henry Luce Foundation for providing the Parrish with the wherewithal to publish this volume, to delve deeply into the strengths of the collection, provide original scholarship, and illuminate the important contributions that the collection makes to the understanding and appreciation of the rich tapestry of American art. We are confident that this publication, the first in a series dedicated to illuminating the treasures of the Parrish collection, reflects the quality of our holdings and the tradition of scholarship that has marked the Parrish from its beginnings.

Terrie Sultan
Director

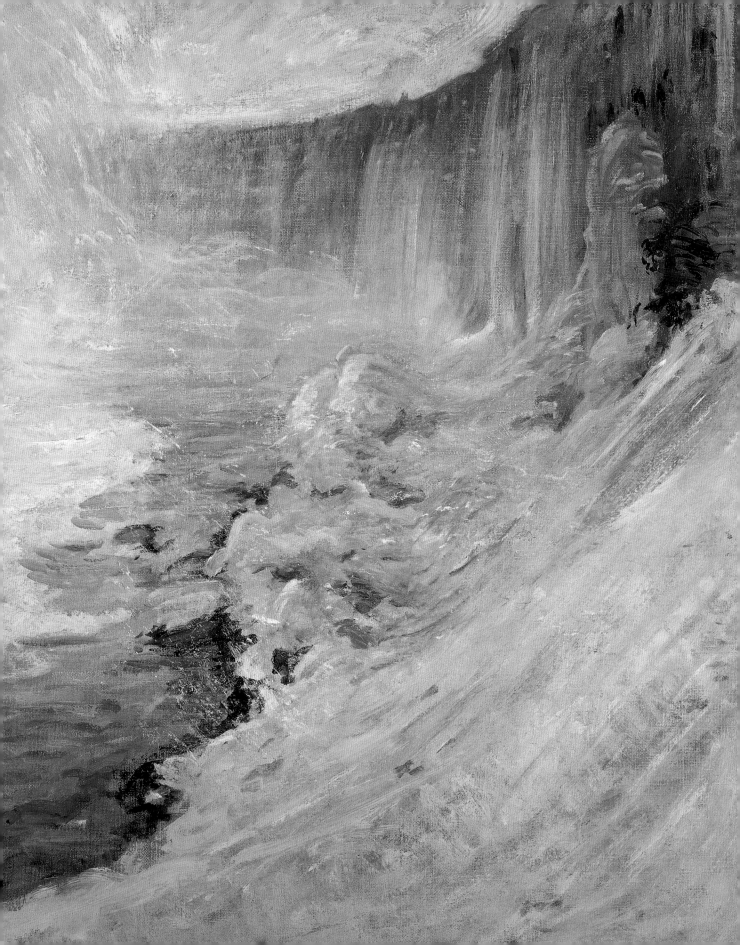

AMERICAN LANDSCAPE PAINTING
In the Eye of the Beholder

American art abounds with landscape images that shape our view of nature. The canvas is a window onto aspects of the natural world around us, made "real" by the skills of the artist in delineating or invoking that world in two dimensions. The landscapes in the collection of the Parrish Art Museum trace the history of the genre in American art from the early nineteenth-century birth of a national school to the era of contemporary artists, many of whom live and work on Long Island's East End. These works chronicle a rich and nuanced narrative of individual responses to the natural world.

In scaling the heights of nature and framing the long distance into the wilderness, the first American artists were inventing a vision of the vast continent. By the middle of the nineteenth century, the border of the wilderness had been pushed farther and farther west and industrialization had inexorably begun to transform the topography of the eastern United States. Artists working after the Civil War, many of whom traveled to Europe to study, responded to such changes in their choice of landscape subject matter and their increased awareness of European painting techniques, both the naturalism of the French Barbizon painters and the optical effects of the Impressionists. The drama and carefully composed structure of the majestic landscape gave way to the meticulous naturalism of a more intimate view, often evoking a specific place, with light and color employed to astonishing effect. Gradually freed from convention, artists had more choices of ways to paint.

As viewers, we have necessarily personal tastes in landscape art. We seek out ways to support our observations of nature, from picture postcards to scenic overlooks. Eighteenth-century travelers were motivated by their own enthusiasms, sometimes almost to the point of distraction; the craze may have been started by the English cleric and amateur artist William Gilpin (1724-1804), one of a number of writers in the eighteenth century who sought to organize the viewing of nature into a defined system "expressive of that peculiar kind of beauty which is agreeable in a picture."[1] Hordes of tourists and Sunday artists trooped around the English countryside in search of pleasing prospects, equipped with a small tinted convex mirror that when held at arm's length reflected the distant view, perfectly contained in the Reverend Gilpin's notion of "the picturesque" (figure 1).

This optical device was known as a "Claude glass," named for the seventeenth-century French painter Claude Lorrain (1604-1682), who in his works "had so perfectly

1 As quoted in Geoffrey Batchen, *Burning with Desire: The Conception of Photography* (Cambridge, Massachusetts: The MIT Press, 1999), 72.

John Henry Twachtman: *Horseshoe Falls, Niagara* (large detail), ca. 1894

Figure 1
The Rev. William Gilpin (British, 1724–1804)
View from the Bank of a River
Watercolor on paper, 6 × 9 inches (oval)
Victoria and Albert Museum, London

Figure 2
Thomas Gainsborough (British, 1727–1788)
Study of a man sketching holding a Claude glass, ca. 1750–1755
Pencil on paper, 7 ¼ × 5 ⅜ inches. The British Museum, London

harmonized classical architecture, leafy groves and distant water."[2] Small enough to fit in the hand, the mirror was backed with a dark foil that helped eliminate the chromatic range in the reflection, revealing only the tonalities. In promoting the use of the Claude glass, the Reverend Gilpin noted that it "give[s] the object of nature a soft, mellow tinge like the colouring of that Master"[3] (figure 2). The convexity of the mirror curved the sides of the image inward so that trees on the edges appeared to bend toward the center and frame the view. In this way, nature became more pleasing when parsed into recognizable and familiar "pictures."

EARLY PRACTITIONERS

In the early days of this nation, most practicing artists were portrait painters. There was neither the taste nor the demand for landscape vistas. But by the 1820s, American artists had joined literary figures in recording the "New Eden"—a place neither invented nor recollected, but empirically evident in the vastness of the North American continent. This wilderness prompted Thomas Cole (1801-1848), the leading figure in the Hudson River School, to write in his 1835 "Essay on American Scenery" that "American associations are not so much of the past as of the present and the future."[4] Memory was short, and the natural wonders of the New World were superior to the man-made monuments of Europe. However much Cole advocated the rejection of Old World subjects for the panoply of New World inspiration, he did not repudiate the Claudian principles of composition that had dominated painting for the better part of two centuries.

Many of the first generation of homegrown American painters came from New York or Philadelphia. Those who lived farther afield soon made their way to these artistic meccas for study at the Pennsylvania Academy of the Fine Arts, founded in 1805, or at

2 Simon Schama, *Landscape and Memory* (London: HarperCollins, 1995), 11.

3 William Gilpin, *Three Essays: on Picturesque Beauty; on Picturesque Travel; and on Sketching Landscape*, second edition (London, R. Blaimire, 1794), 26.

4 John W. McCoubrey, *American Art 1700–1960: Sources and Documents* (Englewood Cliffs, New Jersey: Prentice Hall, 1965), 108.

the National Academy of Design in New York, founded in 1825. Some began their career in the field of engraving, as did the British-born Thomas Birch, whose apprenticeship to his father, a noted miniature painter and engraver, influenced the development of a meticulous style in painting (plate 1). Thomas Doughty's *The Anglers* of 1834 demonstrates a clear understanding of Claudian models (plate 2). Asher B. Durand opened a successful engraving business in New York, publishing copies of well-known paintings, before pursuing a career as a landscape painter (plate 3). In two generations, the artists of the Hudson River School established a syntax for the expression of American ideals.

POSTWAR STRATEGIES

Artists coming of age in the 1860s were not convinced that the diligently composed structures and dramatic effects of Hudson River School landscapes were their only painting options. Some, including Samuel Colman (plate 7), George Henry Smillie, and William Trost Richards, chose a close-up study of nature, taking a cue from the naturalistic observations in paint of the French Barbizon School. The work of American followers of the Barbizon painters is often referred to as Tonalism, and this movement, especially strong in the 1880s, 1890s, and early 1900s, signaled the end of Hudson River School orthodoxy and, in the hands of an original artist such as Albert Pinkham Ryder, a path to modernism.

The French artists who traveled to the village of Barbizon on the edge of the ancient forest of Fontainebleau selected the most appealing sites. They were soon joined by fashionable Parisians who flocked to the woodlands as well; by 1860, 100,000 visitors were regularly recorded on a clement Sunday. The leading Barbizon painters were Jean-Baptiste-Camille Corot (1796–1875) and Charles-François Daubigny (1817–1878). Among their American followers, Smillie's approach was characteristic: he continued to refine his renderings of landscape throughout his life (plate 9). Later in his career he wrote, "The longer man lives the simpler grows the composition."[5] Richards stopped at nothing to achieve greater accuracy in his works; he often stood in the surf to make quick sketches that would serve as source material for his studio paintings (plate 20). Before the middle of the nineteenth century, work in the studio was considered superior to directly transcribing from nature by painting outdoors. This attitude shifted, however, and painting spontaneously from nature became a value in and of itself. As the first wave of European-trained artists returned to the United States in the 1870s, there seemed to be an infinite range of possibilities in paint.

5 John Wilmerding, *American Masterpieces from the National Gallery of Art* (New York: Hudson Hills Press, 1988), 73.

THE TRUTH IS TOLD ABOUT THE WHOLE:
JOHN RUSKIN AND AMERICA

We tend to think of landscape painting as a fairly traditional and conventional genre, but unfettered by religious or historical constraints, it was a radical idea in the first half of the nineteenth century. The English artist and critic John Ruskin (1819-1900) dedicated his book *Modern Painters*, published in five volumes from 1843 to 1860, to the "Landscape Artists of England." Ruskin's book was widely read in Britain and in the United States. The volumes deconstruct every aspect of landscape, from cloud types, to the shape of leaves, to rock formations. "For stone, when it is examined, will be found a mountain in miniature."[6] One of his studies (figure 3), a watercolor made in Chamonix, Switzerland, and included in an exhibition of British art that opened at the National Academy of Design in 1857, and traveled to Philadelphia and Boston, became a touchstone for the discussion of Ruskinian principles in the United States. An 1863 article titled "Naturalism and Genius," which appeared in *The Crayon*, a journal published by Americans closely aligned with Ruskin and the English Pre-Raphaelites, featured a discussion on the drawing of the boulder. "There is no attempt at 'general effect.' The truth is told about the whole."[7]

Ruskin's influence is seen in the work of many American artists, among them William Stanley Haseltine, David Johnson (plate 4), Thomas Moran (plate 8), and Richards. Ruskin was among Moran's most enthusiastic admirers; when he mistakenly attributed a Moran sketch of the Grand Canyon to Turner, it was high praise, since Turner occupied a singular place in Ruskin's pantheon of artists. Ruskin advocated an art that would serve both science and nature in a modern approach to landscape.

AMERICAN ARTISTS ABROAD

For most Americans studying art in the decades after the Civil War, a journey to Europe was an imperative. Those not of independent means were often sponsored by wealthy patrons. As William Merritt Chase said in 1871 to the St. Louis businessmen who raised $2,100 for him to study abroad, "My God, I'd rather go to Europe than go to heaven." It was recounted of Nicholas Longworth, a prominent Cincinnati businessman and patron of the arts, that "there was never a young artist of talent who appeared in Cincinnati, and was poor and needed help, that Mr. Longworth, if asked, did not willingly assist him."[8]

Often the visit to Europe was a stay in Paris, where one of the most popular places to study was the atelier of the celebrated painter Jean-Léon Gérôme (1824-1904). American

6 John Ruskin, in *Modern Painters*, Volume IV, Part V, "Of Mountain Beauty" (New York: John Wiley & Sons, 1885), 304.

7 As quoted in Linda Ferber and William H. Gerdts, *The New Path: Ruskin and the American Pre-Raphaelites* (Brooklyn: The Brooklyn Museum and Schocken Books, 1985), 285.

8 Worthington Whittredge, *The Autobiography of Worthington Whittredge* (New York: Arno Press, 1969), 17.

Figure 3
John Ruskin (British, 1819–1900)
Fragment of the Alps ca. 1854–1856
Watercolor and gouache over pencil
on paper, 13 ¼ × 19 ½ inches
Harvard Art Museum, Fogg Art Museum,
Cambridge, Massachusetts, Gift of Samuel Sachs

artists also frequently enrolled for a year or more of instruction at the Royal Academy in Munich, where Chase studied, or Düsseldorf, the choice of Haseltine and T. Worthington Whittredge (1820–1910) in the 1850s. William Lamb Picknell worked in important French artists' colonies, including Pont-Aven on the Brittany coast (plate 6). Haseltine made Rome his home after 1870, often painting scenes of Capri or the Amalfi coast that appealed to American collectors (plate 14). Theodore Robinson first traveled to Giverny in the late 1880s with an introduction to the village's most famous artist-in-residence, Claude Monet, and remained there for four years (plate 16). Whether for a briefer or a more extended stay, Europe was where American artists looked for instruction and inspiration. The challenge upon returning home was to find a way to contribute to a distinctly American Art.

PICTURESQUE AMERICA
"THE GREATEST COUNTRY IN THE WORLD FOR SCENERY"

The picturesque, once it took hold, was hard to forsake. "There is no denying the fact," one artist commented, "that the early landscape painters of America were too strongly affected by the prevailing idea that we had the greatest country in the world for *scenery*...and the only way to get along was to paint *scenery*."[9]

This situation was only intensified in the post-Civil War years by the debut of *Picturesque America, or The Land We Live In*, first published as a series of articles in *Appletons' Journal*, a weekly magazine of literature, science, and art. It was later issued in book form, edited by William Cullen Bryant, in two parts, in 1872 and 1874, and reached wide distribution, with more than 100,000 copies in American homes.

The preface to the book stated that in the "old world every spot...had been visited by the artist; studied and sketched again and again."[10] There were some nine hundred illustrations, by chief illustrator Harry Fenn, and Thomas Moran, John Frederick Kensett,

9 Ibid., 53.
10 William Cullen Bryant, ed. *Picturesque America, or The Land We Live In* (New York: D. Appleton, 1872), v.

W. S. Haseltine, James D. Smillie, and others (figure 4). These volumes were the first to celebrate the country, including the Far West, as a reunited whole after the Civil War.[11]

EXPRESSIVE PAINT

By the end of the nineteenth century, to be modern as an artist often meant to be occupied more with conveying internal emotions than with transmitting objective facts about the world. For Albert Pinkham Ryder, the handling of paint as a physical property was of primary concern; the subject matter of the painting was not the actual places or characters depicted but rather the mood he was able to create (plate 12). Form tended to dissolve, and artists in succeeding generations, Jackson Pollock among them, have responded viscerally to the insistent physical presence of paint on the surface of Ryder's canvases. As a young man Ryder studied at the National Academy of Design and found relief from the stifling classroom atmosphere only while painting outdoors in the summer. He recalled an epiphany that eerily anticipates Pollock's famous assertion, when asked if he worked from nature, "I am Nature":

> When I grew weary with the futile struggle to imitate the canvases of the past, I went out into the fields, determined to serve nature as faithfully as I had served art...Try as I would, my colors were not those of nature...One day before my eyes framed in an opening between two trees [the scene] stood out like a painted canvas... Three solid masses of form and color—sky, foliage, and earth—the whole bathed in an atmosphere of golden luminosity. I threw my brushes aside; they were too small for the work in hand. I squeezed out big chunks of pure moist color and taking my palette knife I laid on blue, green, white, and brown in great sweeping strokes...I saw nature springing into life upon my dead canvas. It was better than nature, for it was vibrating with the thrill of new creation.[12]

For Martin Johnson Heade, the depiction of the effects of light on water, especially the coastal salt marshes of New England and the swamps of Florida, was a consuming study (plates 18 & 19). He and other painters who pursued this style have come to be known as Luminists. John Francis Murphy was noted for the overall atmospheric tonality of his compositions. By 1900 his landscapes were characteristically filled with the

11 Sue Rainey, *Creating Picturesque America: Monument to the Natural and Cultural Landscape* (Nashville: Vanderbilt University Press, 1994), xiii.

12 Albert Pinkham Ryder, "Paragraphs from the Studio of a Recluse," *Broadway Magazine*, September 1905, 10–11, as quoted in McCoubrey, *American Art 1700–1960*, 187–188.

prevailing colors of autumn, an indication perhaps of his own emotional state more than any straightforward observation of nature (plate 26).

AMERICAN IMPRESSIONISM

By the last decades of the nineteenth century, American painters were searching for new modes of expression. The early nineteenth-century hegemony of the Hudson River School gave way to a pluralism in artistic approaches that reflected the influence of the French Impressionists' brighter palette and more vibrant brushwork. The grandiosity of the early panoramas was replaced by a more intimate scale. Perhaps no two paintings demonstrate this disparity more readily than Cole's 1830 depiction of Niagara Falls (figure 5) and John Twachtman's *Horseshoe Falls, Niagara* (ca. 1894; plate 17). Cole wrote: "And Niagara! That wonder of the world!—where the sublime and beautiful are bound together in an indissoluble chain. In gazing on it we feel as though a great void had been filled in our minds—our conceptions expand—we become a part of what we behold!"[13] For Cole, Niagara is an intellectual activity, quite literally filling a void. For Twachtman, Niagara is a personal experience.

Practitioners of American Impressionism were generally a loose confederation. But in 1898 a group of painters did band together in opposition to the hidebound character of the art establishment. They were dubbed "The Ten."[14] Most had studied in Paris during the 1880s. In 1893 the work of Twachtman and J. Alden Weir (1852–1919) was shown at the American Art Galleries in New York alongside that of Monet and Paul-Albert Besnard. A reporter noted: "Here is a treat for the apostles of light and air and the hot vibrations of sunlight in painting; for the devotees of simple abstract color and illumination. It is also a fine opportunity to compare the works of Monet, the most conspicuous of Parisian impressionists, with those of two of our own most advanced followers in his footsteps."[15]

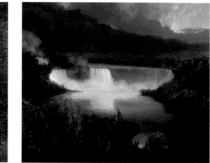

Figure 4
East Hampton, from the Church Belfry
engraving from *Picturesque America* (1874)

Figure 5
Thomas Cole (American, 1801–1848)
Distant View of Niagara Falls, 1830
Oil on panel, 18 ⅞ × 23 ⅞ inches
Friends of American Art Collection,
The Art Institute of Chicago

13 Thomas Cole, "Essay on American Scenery," *The American Monthly Magazine*, January 1836, as quoted in McCoubrey, 105.

14 Thomas E. Dewing (1851–1938), Edward E. Simmons (1852–1931), J. Alden Weir (1852–1919), John Henry Twachtman, Joseph R. De Camp (1858–1923), Willard L. Metcalf (1858–1925), Childe Hassam, Frank Benson (1862–1951), Robert Reid (1862–1929), and Edmund C. Tarbell (1862–1938); William Merritt Chase took Twachtman's place after the latter's death in 1902.

15 "A Group of Impressionists," New York *Sun*, May 5, 1893, 6.

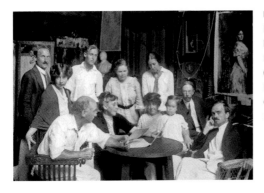

Figure 6
Painters assembled in the Wiles Studio, Peconic, ca. 1914
l. to r.: Henry Prellwitz, Gladys Wiles, Edward August
Bell (seated), Edwin Prellwitz, Edith Mitchill Prellwitz
(seated) Edith G. Bittinger, May Wiles (seated), Julia O.
Bell, Isabel Bittinger (child), Irving Ramsey Wiles, and
Charles Bittinger (seated). Private Collection, Peconic,
New York

ART COLONIES

The idea of the exurban art colony in Europe is directly traceable to the beginnings of
plein-air (open-air) painting at Barbizon. The growing economic prosperity of the 1880s
and 1890s in the United States meant that, come summer, many city dwellers in the
Northeast could expect to seek the cooler temperatures of the Long Island, Connecticut,
and Massachusetts shorelines. Artists were a part of this annual migration, and art schools
and artists' colonies were established on the East Coast, notably at Cos Cob in Connecticut
and at the Shinnecock Hills Summer School of Art near Southampton, New York, in the
early 1890s. Childe Hassam explored various Atlantic coastal resorts, including the Isles of
Shoals off New Hampshire, before settling in East Hampton in 1919 (plate 22). Edith and
Henry Prellwitz (plates 21 & 24), along with Irving Ramsey Wiles (plate 23) and Edward
August Bell (1862–1953), formed their own small colony on Long Island's North Fork in
Peconic (figure 6). Wiles promoted his fledgling art school there by assuring prospective
students that, unlike the village of Southampton, Peconic was not "a 'summer resort,' but
a rural town chosen for its surrounding scenery which is peculiarly picturesque; for the
quietness of the place; and its facilities for board, travel, etc."[16]

Ernest Lawson (plate 25) studied with Twachtman at his school in Cos Cob in
the 1890s. And in 1914, John Sloan spent his first summer on Cape Ann in Gloucester,
Massachusetts (plate 28). Robert Henri returned again and again to Monhegan Island,
off the coast of Maine (plate 29). Guy Pène du Bois launched his own school of art in
Stonington, Connecticut, in the 1930s (plate 30). These locations have traditionally
afforded the respite and refreshment essential for artistic inspiration.

16 Brochure for Peconic summer art
 classes, Southold (New York) Histori-
 cal Society, n.p.

MODERNISM IN THE AIR

The tide of artists studying abroad slowed somewhat after the upheaval of World War I. There were American artists in Paris in the 1920s, but they were more likely to be painting in their own studios and breathing in the atmosphere of the cafés along the Boulevard Montparnasse than to be in an academic setting. New York had exhibitions of modern European art, most notably at Alfred Stieglitz's gallery 291, which featured Rodin, Cézanne, and Picasso in the early years of the century. The Armory Show of 1913 was a defining experience for many American artists, who saw modern European art in depth for the first time there. Sloan observed that "the blinders fell from [my] eyes."[17] Although he would never paint abstractly, he encouraged young painters to bolster "the best academic principles with the 'stimulating discoveries' of modern art and 'then forge ahead for creative self-expression.'"[18]

It is worth noting that, of the twenty-two galleries of the Armory Show, four were devoted to a history of the modernist movement, including work by Ingres, Manet, Cézanne, and Van Gogh. The only American considered was Ryder, selected by the young generation of artists who organized the exhibition, including Henri. At the Armory Show, Ryder's position as "an American 'old master' and the only native prophet of modernism" was formally acknowledged.[19] His contribution was measured not in terms of his retreat to myth-imbued subject matter but in terms of his experiment in abstraction.

FROM MY BACKYARD

Charles Burchfield once joked that he could have a show of his work titled "From My Backyard", so close did he stay to his house in Gardenville, New York, outside Buffalo. "I will always be an inlander in spirit. The ocean. . .does not lure my imagination. Without discounting its awe-inspiring grandeur, it is not for me, and surely it has a worthy rival in a hay or wheat field on a bright windy day."[20] Burchfield was able to calligraph with his agitated line the energy and intensity of nature (plate 34).

Many twentieth-century artists who take on the subject of landscape seem to paint what they are closest to. Some are forever identified with the aspect of nature they typically depict. John Marin's persona is indelibly linked with the rocky coast and inland topography of Maine, a quintessentially American identity (plate 33). A poll of forty art critics and museum directors and curators, as well as a separate survey of artists, published in *Look* magazine in February 1948, arrived at the same conclusion and named Marin "America's Artist No. 1."[21]

17 Sloan's unpublished notes, as quoted in David Scott, *John Sloan* (New York: Watson-Guptill, 1975), 116.

18 Ibid., 120.

19 Elizabeth Broun, *Albert Pinkham Ryder* (Washington and London: Smithsonian Institution Press, 1989), 4.

20 As quoted in J. Benjamin Townsend, ed., *Charles Burchfield's Journals: The Poetry of Place* (Albany: State University of New York Press, 1993), 37.

21 "Are These Men the Best Painters in America Today?," *Look*, February 3, 1948, 44. The artists whom Marin bested include (ranked in descending order): Max Weber, Yasuo Kuniyoshi, Stuart Davis, Ben Shahn, Edward Hopper, Charles Burchfield, George Grosz, Franklin Watkins, Lyonel Feininger, and Jack Levine.

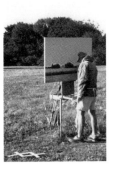

Figure 7
Sheridan Lord, with viewfinder on
grass at left, painting neighboring
Kinkade farm, September, 1993

In the autumn of that year, the rival *Life* convened a roundtable discussion among modern art critics, museum officials, and cultural pundits, in which they undertook "to clarify the strange art of today," and then published the results, a wide-ranging discussion of artists from Matisse to Pollock, in an October issue of the magazine.[22] By August of the next year, *Life* printed the now famous photograph of Pollock, cigarette dangling from his lips, standing in front of *Summertime: Number 9A* (1948), headlined with the provocative query "Is he the greatest living painter in the United States?" Pollock has come to be indelibly identified with his surroundings at Accabonac Harbor in Springs, Long Island ("I am Nature").

In the paintings of three artists who have lived and worked on Eastern Long Island, the landscape and how we frame that image is of primary importance. For a generation of painters that emerged when Abstract Expressionism held sway, choosing to depict the landscape was not a simple decision. Yet Jane Freilicher, who studied with Hans Hofmann, was never persuaded by the dissolution of form. She found herself "in need of the seen,"[23] as the curator and critic Klaus Kertess has phrased it, and in a practice that has been shaped by the view from her studio in Water Mill and the cityscape from her Greenwich Village window, Freilicher has unflinchingly painted what she sees before her (plate 36). A photograph of Sheridan Lord painting in a field reveals, on the ground next to him, two Ls of cardboard that he used as a viewfinder (figure 7). Lord never ventured far from his property in Sagaponack in search of subjects for his panoramic vistas. When development continued to menace the unobstructed view, he eventually gave up painting the landscape (plate 39). Conceptualism was the dominant mode of art-making when April Gornik entered graduate school. To her surprise, she found herself attracted to landscapes, not knowing exactly where the impulse came from. When she subsequently encountered American Luminist painting, it was for her "like getting a call from a long-lost relative."[24] For Gornik, photography furnishes a visual *aide-mémoire* for a landscape conceived in the mind's eye (plate 40). For many of us, American landscape painting makes a similar connection with something innate and ineffable. It is the imagery that we carry with us.

22 Russell W. Davenport, "A *Life* Round Table on Modern Art," *Life*, October 11, 1948, 62.

23 Klaus Kertess, *Painting Horizons: Jane Freilicher, Albert York, April Gornik* (Southampton, New York: Parrish Art Museum, 1989), n.p.

24 Donald Kuspit, "Fictional Freedom: April Gornik's Landscapes," in *April Gornik: Paintings and Drawings*, exhibiton catalogue (New York: Hudson Hills Press, 2004), 12.

PLATES

THOMAS BIRCH American, b. England, 1779–1851

Thomas Birch was born in England and emigrated to the United States in 1794 with his family, who settled in Philadelphia. His father, William Russell Birch (1755–1855), a noted painter and engraver, had come to this country with letters of introduction from prominent figures in Britain, Benjamin West among them, and set himself up as a painter and teacher. Young Thomas received his first instruction from his father, developing a meticulous painting style, and joined the elder Birch in a thriving business producing engravings from their landscapes and seascapes, under the name Wm. Birch and Son.

The younger Birch became known for his depictions of the sea, and engravings made from his paintings were in wide circulation. He is perhaps best remembered for his scenes in and around the busy harbors of Philadelphia and New York. In these canvases, ships, steamboats, and buildings onshore are rendered in highly accurate detail, in marked contrast to the looser handling of the sky, which is often reduced to a mélange of pink and blue tones.

Birch's paintings of naval engagements during the War of 1812 proved especially popular with a young nation heady from victory over Britain's vaunted power. Such scenes of war are distant from the placid vista of *Fishing Boats*, a paean to the industry and productiveness of the new nation. The array of different types of vessels attests to the vigor of the shipping trade: the rowboat with fishing nets piled up in the stern, the small skiff unfurling its sail, single- and double-masted sailboats, and a clipper ship under full sail in the distance signal the prosperity of the nation and the resourcefulness of its populace.

The most established practitioner of marine painting in America, Birch uses standard conventions to shape the composition—the strong diagonal of the promontory on the right is repeated in the two small craft in the central foreground. A solitary log floating in the left foreground—a device that Birch frequently employs—creates a point of interest. However, since, as the limp flag on one mast reveals, there is not much wind, the main focal point is the small rowboat in the center. Four oarsmen move rapidly through the water, their energetic rowing punctuated by the tiny whitecaps where the oars meet the water.

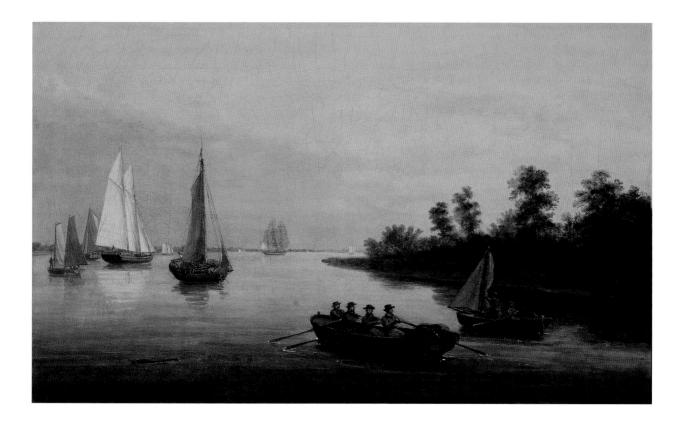

1

Fishing Boats
ca. 1820
Oil on canvas
17 ⅜ × 28 ⅝ inches
Signed lower right: T. Birch
Clark Collection, 1958.4.3

THOMAS DOUGHTY American, 1793–1856

Thomas Doughty was one of the first American-born artists to declare himself a landscape painter, and his works were variously annotated in contemporary catalogues as studies "from nature" or "from recollection" or as "fanciful" landscapes. Born in Philadelphia, in his early twenties he abandoned an apprenticeship to a leather currier to pursue a career as an artist, a largely self-taught vocation that he would develop by copying paintings in the Pennsylvania Academy of the Fine Arts. An exhibition there in May 1816 included his painting *Landscape–original*, one of the few on display that did not draw its subject from portraiture or history painting.[1] To judge from the title, this tyro wanted to make clear to his audience that his efforts were entirely his own and not mere imitations.

In the mid-1830s, the period from which *The Anglers* dates, Doughty's work enjoyed wide popularity. Unlike some other American artists, he had not made a trip to Europe for firsthand viewing of the Old Masters, but nonetheless he had absorbed the lessons of Claudian models: trees frame the composition, a darkened foreground pushes the eye into the distance, a body of water occupies the middle ground, and mountains rise in the distance.

And yet Doughty has taken the model and expanded it. Springing up from the largely indistinct foreground on the right of the composition, an expressive tree gracefully arcs to frame the center. The strong interest in the modeling of the rocks in the left foreground and the energy and force of the central cascading brook suggest an empiricism that delights in the direct observation of nature—a characteristic that would be a hallmark of American painting, distinct from its European precedents.

In many of Doughty's paintings, a centrally placed figure acts as a stand-in for the viewer. Here, Doughty puts the angler in a bright red jacket, not an unusual color for a gentleman's outdoor sporting attire, but still a skillful device to draw the eye.

Doughty's placid landscapes, for the most part devoid of the man-made, reinforced the image of America as the "New Eden." Only gradually did public taste come to prefer the sublime images of nature as depicted by his contemporaries Thomas Cole and Asher Durand.

1 Frank H. Goodyear, *Thomas Doughty, 1793–1856: An American Pioneer in Landscape Painting* (Philadelphia: Pennsylvania Academy of the Fine Arts, 1973), 12.

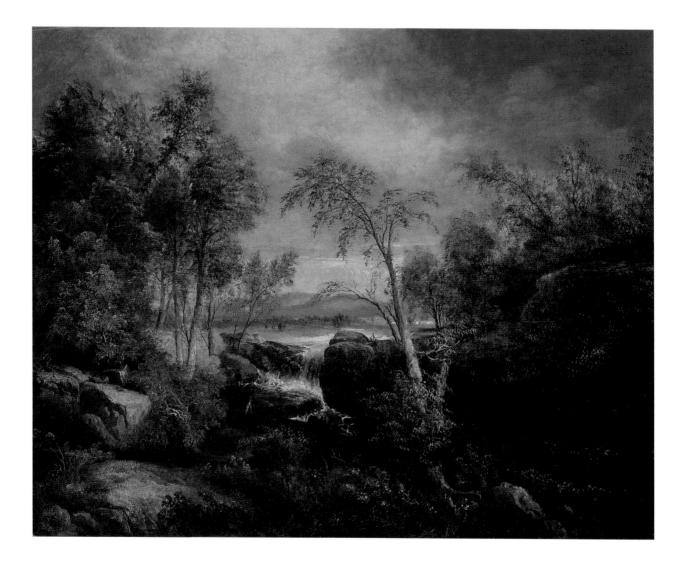

2

The Anglers
1834
Oil on canvas
27 ¼ × 34 ½ inches
Signed lower right: T. DOUGHTY / 1834
Littlejohn Collection, 1961.3.47

ASHER B. DURAND American, 1796–1886

After the death of Thomas Cole in 1848, leadership of the Hudson River School passed to Asher B. Durand. At an early age, he had been apprenticed to Peter Maverick, a prominent engraver in his home state of New Jersey. The two eventually went into partnership and opened a business in New York City, and by the mid-1820s their firm had attained considerable success in producing banknotes, book illustrations, portraits, and copies after other artists' work. Durand was pursuing a parallel path on his own, drawing from casts at the American Academy of Fine Arts. By 1826, he was a founding member of the National Academy of Design. His friendship with Cole bolstered his decision to become a landscape painter, and an 1837 sketching trip to the Adirondacks with Cole secured this new path. The following year Durand submitted nine paintings to the Academy's annual exhibition.

A trip to Europe with fellow artist John F. Kensett (1786-1829) in the summer of 1840 exposed Durand to the work of the Old Masters that he had studied for so long. He confided in his journal that Claude Lorrain did not "surpass [his] expectations." This disenchantment with the closely held artistic conventions of the time must have sealed Durand's determination to paint from nature. Later that summer he wrote to his wife from Geneva: "I have found an agreeable change from the previous study of pictures to the study of nature, and nature too, in her utmost grandeur, beauty, and magnificence."[1]

For Durand, nature and progress were not opposing forces. In *Landscape*, there is little empathy for the figure of the Native American in the foreground, and no nostalgia for the vanishing scene he witnesses. A "lesser" civilization has simply yielded to a more "advanced" one. Durand often found himself in accord with the English critic and reformer John Ruskin (1819-1900), who saw moral analogies in the depiction of nature. In his 1855 "Letters on Landscape Painting," Durand wrote about a nature "fraught with lessons of high and holy meaning."[2]

1 As quoted in Barbara Novak, *Nature and Culture: American Landscape Painting, 1825–1875* (New York: Oxford University Press, 1980), 231.

2 John W. McCourbey, ed., *Sources and Documents: American Art, 1700–1960* (Englewood Cliffs, New Jersey: Prentice Hall, 1965), 112. Originally published in *The Crayon*, 1855.

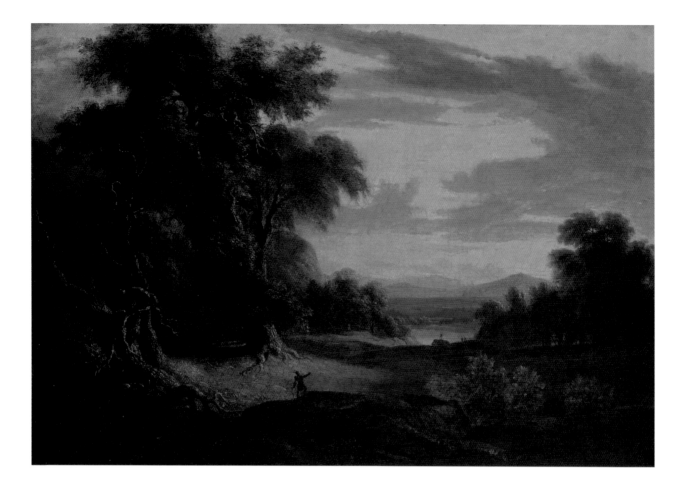

3

Landscape
ca. 1844
Oil on canvas
29 ¼ × 42 ⅜ inches
Littlejohn Collection, 1961.3.251

DAVID JOHNSON American, 1827–1908

Second-generation Hudson River School painter David Johnson eschews the pyrotechnics of his more celebrated artistic forebears such as Cole and Durand, and focuses instead on the knowing detail. His career was centered in New York City, where he was born, and although he claimed to be self-taught, he studied for several years at the National Academy of Design, where fellow students included Frederic E. Church (1826–1900) and Sanford R. Gifford (1823–1880). Johnson also studied briefly with another Hudson River school artist, Jasper F. Cropsey (1823–1900), in West Milford, New Jersey, in 1850.[1]

By the mid-1850s, Johnson was exhibiting regularly at the National Academy of Design. He often summered in the Catskills and in New Hampshire's White Mountains, and *Adirondack Scenery* is typical of his work of the 1860s. Atmospheric effects dissolve the contours of the distant mountain. The painterly concentration on the foreground rocks and trees aligns his work with that of American followers of John Ruskin. The only traces of human activity seen here (the tiny boat with two figures in the right foreground and the Lilliputian village nestled in the distant valley) minimize the hand of man and emphasize the vastness of nature—a prodigious subject given the modest scale of the painting itself.

In the ensuing decades Johnson would concentrate on more intimate landscapes, work that manifested a diligent study of nature. This trend capitalized on the changing tastes of American collectors, who were beginning to acquire the work of the French Barbizon painters, including Théodore Rousseau (1812–1867) and Jean-Baptiste-Camille Corot (1796–1875). Johnson's pastoral scenes earned him the sobriquet "the American Rousseau."

1 Linda S. Ferber, with William H. Gerdts, *The New Path: Ruskin and the American Pre-Raphaelites* (New York: The Brooklyn Museum and Schocken Books, 1985), 270.

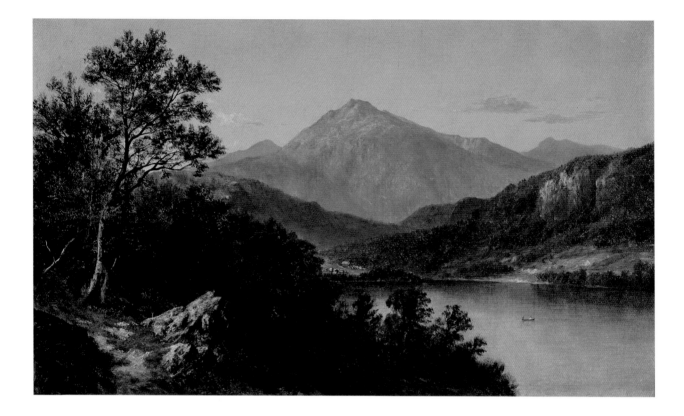

4

Adirondack Scenery
1864
Oil on canvas
12 × 20 ⅛ inches
Museum Purchase, 1954.17

EDWARD LAMSON HENRY American, 1841–1919

Edward Lamson Henry discovered the American taste in the post-Civil War era for meticulous detail, well-manicured nature, and scenes that could be easily read, like the charming view of an old church presented here. Such nostalgic images appealed to a public coping with the aftermath of years of internecine conflict and searching for assurance of a return to normalcy. The past offered an immediate avenue to stability.

Henry became best known for his genre paintings of life in upstate New York's Shawangunk Mountains, in the foothills of the Catskills. He began visiting the area in the late 1870s, and in 1883 he and his wife built one of the first homes in what became the Cragsmoor art colony there. He often incorporated architectural elements into his paintings, including particulars gleaned from photographs and sketches, and he collected costumes and even antique carriages to use in his paintings. By the time he set out to record this scene near his country house, the seventeenth-century Dutch Reformed church had in fact lost its high steeple. In painting such views, Henry was motivated not only by a yearning for a bygone era but also by a keen interest in the preservation of such historic sites, already threatened by rapid expansion and industrialization.

There is much to admire in this sunlit summer scene. In the center foreground, two appealing young girls, both wearing bonnets to protect them from the sun, pick wildflowers as they walk along the steep hillside bordering the church. A group of boys and girls is just visible playing under the large trees in the right of the composition. The tranquil clouds add to the halcyon idyll.

Henry was among the first artists, along with Frederick Samuel Dellenbaugh (1853–1835), Eliza Pratt Greatorex (1819–1897), and John George Brown (1831–1913), to discover this scenic area in the 1870s, when it was known as Ellenville. Dellenbaugh, who had earned fame as an explorer, objected to that apparently prosaic name and lobbied for the more exotic "Cragsmoor" when the town petitioned for a post office in 1893. In 1906, the local newspaper, the *Cragsmoor Journal*, recognizing the sophisticated makeup of the village, described it as "a harmonious community...active-minded and deeply interested in the best art, literature, drama and music...These people have seen the world far and wide, yet they find the charms of Cragsmoor undimmed by comparison."[1]

1 As quoted in Steve Shipp, *American Art Colonies, 1850–1930* (Westport, Connecticut: Greenwood Press, 1996), 25.

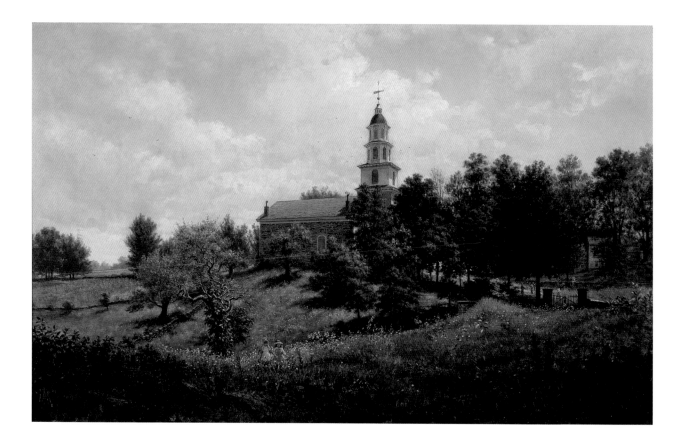

5

The Old Dutch Church, Bruynswick
1878
Oil on canvas
18 ¾ × 29 ⅛ inches
Signed lower left: E. L. Henry / July 1878
Littlejohn Collection, 1961.3.155

WILLIAM LAMB PICKNELL American, 1853–1897

William Picknell spent most of his career painting in France. This work transcribes the glare of the bright sun of southern France, rendering the intense effects of light on the surface of the natural forms.

Picknell was born in Vermont, and his family moved to the Boston area after the death of his father. A sympathetic uncle, recognizing his nephew's talent and earnestness, provided the means for him to study abroad. Picknell traveled to Italy, where he painted alongside George Inness (1825–1894) in 1872–1874 and absorbed the artist's lessons of art as a conveyor of spiritual feelings. In the spring of 1874, Picknell came under the tutelage of the American painter Robert Wylie (1839–1877) at Pont-Aven, a gathering place for French and, increasingly, American painters on the Brittany coast.

In *A French Garden, Provence*, a young woman stands outside a thatch-roofed whitewashed house. The light comes from the left at a low-raking angle, indicating an early hour in the day, as does the young woman's appearance, with no parasol or hat to protect her from the sun. At her feet a stony path adds a graceful curve to the composition, winding around a flower bed and spilling into the left foreground edge of the composition; this device would become a signature of Picknell's work. The woman has turned away from the sun, the light hitting only the back of her neck; her face is in shadow. The glancing light throws the flowers into high relief. The sky visible over the rooftop is a brilliant violet blue with only the slightest tinge of white. The art historian William Gerdts has singled out Picknell's extraordinary ability to capture the effects of strong sunlight on surfaces; Gerdts coined the term "glare aesthetic" to describe this interest in:

the effects of intense daylight, portrayed in strong tonal contrast, often achieving the powerful effect of glare from reflective surfaces. . .They are mirrors from which dazzling sunlight is reflected. . .toward the spectator and upon which strong silhouettes of still clearly rendered forms may be cast, allowing for the intensification of color and light without dissolution of form.[1]

Two years after he painted this picture in Provence, Picknell claimed the distinction, at age twenty-six, of being the first American landscape painter awarded an honorable mention at a Paris Salon, for *La route de Concarneau* (*The Road to Concarneau*). Picknell returned to the United States in 1882, and lived in the Boston area. He spent summers from 1883 to 1891 at Annisquam on Cape Ann, joined by other artists, Thomas Hovenden among them, who established an art colony modeled on Pont-Aven. From 1893 to early 1897, Picknell rented a villa on the Côte d'Azur. This was to be his last sojourn abroad. Upon learning of the death of his son in 1897, he returned to the United States, only to succumb himself some six months later, at age forty-three. He had spent the last few years of his life in the blazing sunlight of the south of France, which had inspired some of his finest paintings.

1 William H. Gerdts, *American Impressionism* (Seattle: The University of Washington Press and The Henry Art Gallery, 1980), 17.

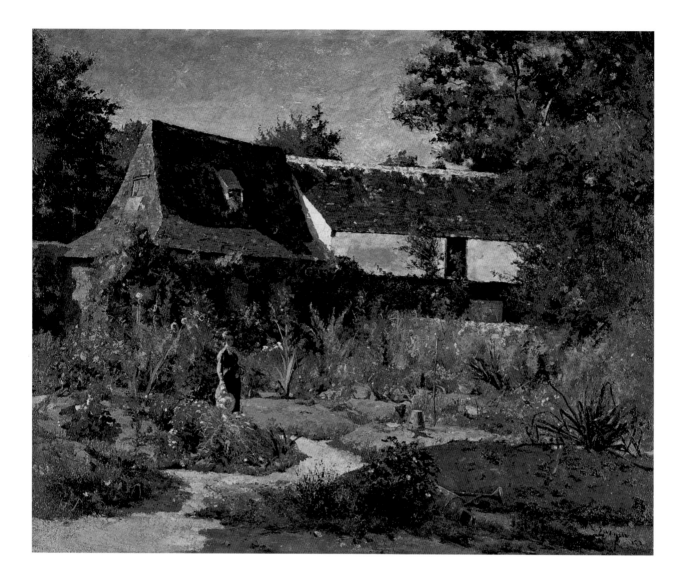

6

A French Garden, Provence
1878
Oil on canvas
23 ½ × 28 ⅝ inches
Signed lower right: W. L. Picknell. 1878
Clark Collection, 1959.6.34

SAMUEL COLMAN American, 1832–1920

Samuel Colman was one of the first artists to visit an eastern Long Island made more accessible in the 1870s by the Long Island Rail Road. The charming village of East Hampton, known for its windmills, colonial-era shingled houses, and placid ponds, was dubbed "the American Barbizon" in an 1883 issue of the popular monthly *Lippincott's*, which acknowledged the growing attraction of the village.

> Besides the artists, a score or so of quiet families made the place their summer quarters; but its characteristic features remained the same,—in every quiet nook and coigne of vantage an artist with his easel, fair maidens trudging afield with the attendant small boy bearing easel, color-box, and other impedimenta, sketching-classes setting out in great farm-wagons carpeted with straw. . .and pleasure-vehicles in the streets.[1]

Colman grew up in New York City, where his father was a bookseller and publisher in lower Manhattan; his enterprise included the publication of engravings of artwork and brought Colman into contact with a clientele that included Asher Durand, who may in fact have tutored the young man. Colman's work was exhibited at the National Academy of Design when he was only eighteen, showing his skill in the dominant mode of the Hudson River School.

By 1880, around the time he painted this picture in East Hampton, Colman had been abroad. He visited France and Spain in 1860–1861 and spent much of the first half of the 1870s in Europe, traveling across the Mediterranean and to Egypt and Morocco. He also explored the American West and made paintings from his trips there.

Colman's return to the rustic setting of *Farmyard, East Hampton* reaffirms the worth of cherished principles and values in the face of a rapidly changing America. The painting evokes a pre-industrial past and nostalgia for a vanishing rural scene, a sentiment that viewers of Colman's work would have easily understood. His choice to omit from the whirring activity of this barnyard scene any human presence may have alerted the viewer to the fragility of a passing way of life. The gathering storm clouds add another portentous note to the pastoral scene and enhance the somber tonality of the painting.

1 Charles Burr Todd, "The American Barbison" [*sic*], *Lippincott's* 5, no. 22 (April 1883), 323–324.

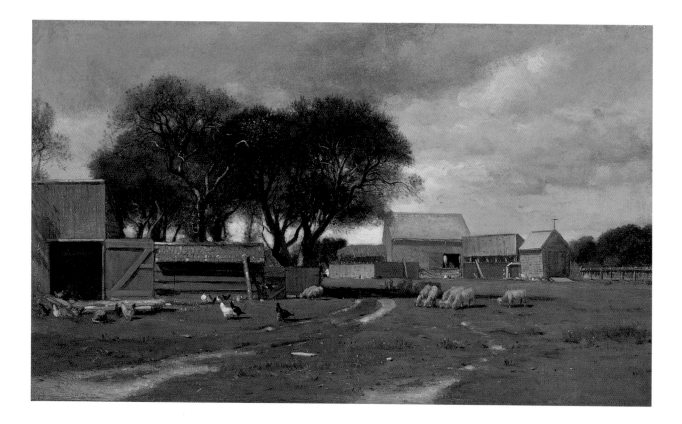

7

Farmyard, East Hampton, Long Island
ca. 1880
Oil on canvas
16 ⅛ × 27 inches
Gift of Walter Knight Sturges, 1958.7

THOMAS MORAN American, b. England, 1837–1926

In September 1882, Thomas Moran and his family were once again in East Hampton, New York, just back from a successful summer exhibition of his work in London.[1] Drawn to the picturesque eastern Long Island village with its broad and shady Main Street, its colonial-era houses, and its community of artists, Moran decided to purchase property there. In 1884 he designed and built a house, The Studio, a gray-shingled, hip-roofed, two-story structure on Main Street, whose great room (forty by twenty-five feet) functioned as both parlor and studio. Moran and his wife, the painter and etcher Mary Nimmo Moran, took the opportunity to work outdoors there in the summer.

Moran made extended trips to the American West and beyond, producing sketches from which he developed full-scale paintings. In 1871 he accompanied a government survey mapping the Yellowstone region. Many of his most famous works come from this expedition, notably *The Grand Canyon of the Yellowstone* (1872), purchased by the U.S. Congress for $10,000. Often, his trips were financed by western railroad companies, seeking to promote their hotels; Moran's paintings were reproduced in chromolithographs that served as advertisements.

From late January to mid-March 1883, the artist journeyed to Mexico. He sailed from New York to Havana and on February 3 arrived at Veracruz, on Mexico's eastern coast, and from there traveled to Mexico City by rail; he returned to the United States via Laredo. The sketches made on this journey form the largest group of his fieldwork from a single excursion.[2] Many sites caught his attention: the town of Orizaba, nestled amid volcanic peaks; the silver mine in Trojes; and the appealing colonial town of Maravatio, where he made the largest number of sketches. In *Maravatio in Old Mexico*, Moran gives us a view of the central square; the church dome and bell tower, pink in the light, are outlined against distant blue mountains. In the foreground women gather by the river, most likely a popular washing place. Moran used a colored paper, drew in pencil, and then applied watercolor. Trees, water, mountains, and sky are all provisional—notations for future reference—and it is precisely this quality of spontaneity that gives his "field sketches" their vibrancy and appeal.

1 Thurman Wilkins, *Thomas Moran, Artist of the Mountains* (Norman: University of Oklahoma Press, 1966), 163

2 Anne Morand, *Thomas Moran: The Field Sketches, 1856–1923* (Norman: University of Oklahoma Press, 1966), 67.

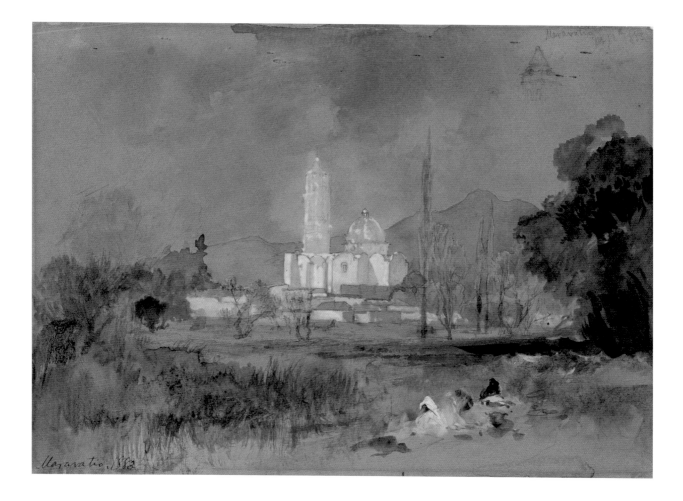

8

Maravatio in Old Mexico
1883
Watercolor and pencil on paper
10 × 14 ⅜ inches
Inscribed lower left: Maravatio, 1883
Inscribed upper right: Maravatio Feb. 12th 1883
Gift of Rebecca Bolling Littlejohn, 1955.10

GEORGE HENRY SMILLIE American, 1840–1921

George Henry Smillie grew up observing the tradition of landscape painting. His father, James David Smillie, Sr., who emigrated from Scotland in 1829, was a prominent engraver in New York City whose reproductions of well-known Hudson River School paintings were a popular commodity. Young Smillie studied at the National Academy of Design, becoming an Academician in 1882. His first paintings were in the predominant Hudson River School style, but by the 1870s his work showed the influence of the free brushwork of the French Barbizon painters.

Smillie first visited East Hampton in 1882 and was captivated by the terrain. In an 1885 article for *The Century*, Lizzie W. Champney noted his delight in the environs of the East End:

> Mr. Smillie finds here a likeness both to England and Holland. The gardens and orchards, the lanes, barns, and shrubbery, are all English; while the meadows stretching to low horizons, the windmills 'with their delicate white vans [sic] outlined against the sky,' are Dutch…[He] paints trees and rocks as the masters of genre paint aged men and women, making every wrinkle and scar tell its story.[1]

The scene that Smillie presents is notably simplified. The most significant feature in the barren foreground field is a small leafless tree. Rough boards have been placed upright around it to form a provisional corral to fend off the grazing livestock. Rustic farm buildings are included, among them a windmill, which assumes prominence because of its central placement in the composition; yet its blades, viewed from an oblique angle, fail to furnish a picturesque silhouette. A stooped figure leans heavily on a stick as he crosses the field on the left; his broad sun hat suggests that the pending storm has arisen suddenly. The real drama has been consigned to the sky as an oncoming cover of clouds obscures the once sunny day, just visible as a bright sliver on the horizon dotted with sailboats.

In a career that spanned the period before the Civil War through the end of World War I, Smillie remained remarkably consistent in his landscape painting, maintaining a compositional format that, as he once observed, is not much more than a horizon line crossed by a diagonal.

1 Lizzie W. Champney, "The Summer Haunts of American Artists," *The Century* 30, no. 90 (October 1885), 850.

9

Farm, Long Island
1883
Oil on canvas
15 ¼ × 23 ½ inches
Signed lower left: Geo. H. Smillie— New York—1883
Gift of Stéphane Samuel and Robert M. Rubin, 2004.13.5

WILLIAM MERRITT CHASE American, 1849–1916

William Merritt Chase spent each summer from 1881 to 1885 in Europe, and the summer of 1883 in Holland with a close friend, the painter Robert Blum (1857–1903). If the years that Chase had spent at the Royal Academy in Munich during the 1870s had established the basic vocabulary of his artistic language, subsequent trips to Europe kept him abreast of the latest trends. The medium of pastel (along with watercolor and etching) enjoyed something of an aesthetic revival in this period. The Society of American Painters in Pastel, as its members called themselves to emphasize their "painterly" concerns, was formed in 1882, and held four exhibitions, in 1884, 1888, 1889, and 1890.

Although known in the United States since colonial days, by the mid-nineteenth century pastel was used primarily for portraiture. Young American painters traveling and studying abroad in the 1870s would have had the opportunity to learn about the extraordinary work in the medium by the French artists Jean-François Millet (1814–1875) and Edgar Degas (1834–1917) and the American expatriate James Abbott McNeill Whistler (1834–1903).

Chase, Blum, and J. Carroll Beckwith (1852–1917), to whom this pastel is inscribed, were founding members of the Society of American Painters in Pastel and participated in its first exhibition in 1884, held at W. P. Moore's gallery in New York. A total of sixty-four works were on view,[1] with nine submitted by Chase, including *A Bit of Holland Meadows*.

The medium of pastel had much appeal for these young painters. Pure dry powdered color mixed with just enough binding material to form into sticks made it portable. With a soft stick, a large amount of paper could be covered with pigment; a harder stick could work as a graphic drawing tool. Pastel is not a forgiving medium, however, and the powder can easily smudge; fixatives were needed to preserve the work. Still, the possibilities for expressive gesture—the hand in unmediated contact with the medium—made pastel especially attractive to young Americans eager to experiment with new ideas.

At first glance, the scene that Chase has chosen has little to recommend it as a subject worthy of artistic scrutiny: it is a fairly ordinary view of a meadow. In the distance, a vessel moves under sail along a canal, and just beyond sit several houses, only their roofs visible. In the sharply tilted foreground two structures echo the rooflines; a sluice furnishes a sharp diagonal. But there is ample opportunity for an uninterrupted study of the possibilities of the color green.

1 Diane Pilgrim, "The Revival of Pastels in Nineteenth-Century America: The Society of Painters in Pastel," *American Art Journal* 10 (November 1978), 48.

10

A Bit of Holland Meadows (A Bit of Green in Holland)
1883
Pastel on paper
23 ⅜ × 28 ⅜ inches
Signed lower left: To my friend / J. Carroll Beckwith / Wm. M. Chase
Gift of Chester Dale, 1962.3.3

WILLIAM G. BOARDMAN American, ca. 1815–ca. 1895

A generation younger than Thomas Doughty and Asher
Durand, William Boardman rapidly absorbed the lessons
of the Hudson River School painters and discovered the
enduring popularity of themes such as the melancholy
of autumn and the allure of opalescent colors. This work
echoes the words of Susan Fenimore Cooper, daughter
of James Fenimore Cooper, who in an essay in *The Home
Book of the Picturesque: or American Scenery, Art, and
Literature* (1852), wrote:

> Autumn is the season for daydreams...
> The softening haze of the Indian summer,
> so common at the same season, adds to the
> illusory character of the view. The mountains
> have grown higher; their massive forms have
> acquired a new dignity from the airy veil which
> enfolds them.[1]

Boardman was born in Cazenovia, New York, near
Syracuse, and attended secondary school there. He began
his art career as a portrait painter in the early 1840s in
Cleveland. From 1848 to 1871 he maintained a studio in
New York City, and exhibited often. He frequently painted
in the Squam Lake region of New Hampshire's White
Mountains in the 1850s and is perhaps best known for
works done there. Boardman is believed to have died at the
age of eighty in Providence, Rhode Island.

1 Susan Fenimore Cooper, "A Dissolving
 View," in *The Home Book of the Picturesque, or,
 American Scenery, Art, and Literature. Comprising
 a series of essays by Washington Irving et al.*
 (Gainesville, Florida: Scholars' Facsimiles &
 Reprints, 1967), 79.

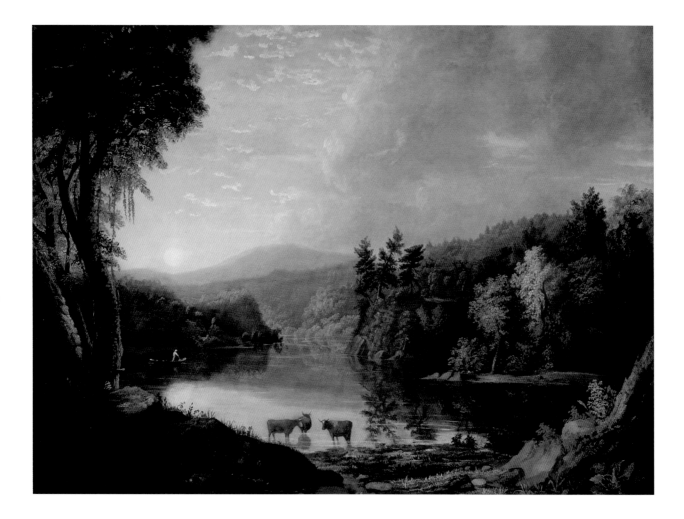

11

Untitled
1885
Oil on canvas
32 ⅝ × 44 ⅛ inches
Signed lower left: W G B
Clark Collection, 1959.6.29

ALBERT PINKHAM RYDER American, 1847–1917

The landscapes of Albert Pinkham Ryder are inhabited by myth, allegory, and parable. His abandonment of the literal transcription of nature in order to convey more fully his own internal emotions has made his work a touchstone for many subsequent artists, including Jackson Pollock. Ryder often worked on his paintings for years, and their surfaces are built up of layer upon layer of paint and varnish.

Born in the New England whaling village of New Bedford, Massachusetts, Ryder received little formal instruction in art until his family moved to New York City when he was in his early twenties. After a failed attempt to enter the National Academy of Design, he studied with the artist William E. Marshall (1837-1906) and later passed the entrance examination.

Ryder traveled abroad several times in the 1880s and 1890s, once with Daniel Cottier (1838-1891), a Scottish art dealer active in London and New York who had befriended him. The artist was less impressed with the Old Masters than with the contemporary Dutch artist Matthew (Matthijs) Maris (1839-1917), with whose moody, tonalist paintings he felt an immediate affinity.

Although Ryder became increasingly reclusive over time, he was far from that in the 1880s and 1890s, his most productive period. He might work on a painting for as many as ten years, and thus the purchase of a Ryder painting, for even his most ardent admirers, was a difficult endeavor. To an impatient buyer he once wrote:

Have you ever seen an inch worm crawl up a leaf or a twig, and then clinging to the very end, revolve in the air, feeling for something to reach something? That's like me. I am trying to find something out there beyond the place on which I have a footing.[1]

1 As quoted in Lloyd Goodrich, *Albert P. Ryder* (New York: George Braziller, 1959), 22.

12

The Monastery
ca. 1885
Oil on wood panel
13 × 9 ⅜ inches
Museum Purchase, Mr. and Mrs. Robert F. Carney Fund, 1988.2

JAMES ABBOTT MCNEILL WHISTLER American, 1834–1903

James McNeill Whistler was the most famous American expatriate artist of the second half of the nineteenth century, and his impact on American art and artists was extensive, despite the fact that he never lived in this country as an established artist. His reputation was made through the inclusion of his works in exhibitions and the critical response to those works. He was not well known personally to fellow American artists until the summer of 1880, when Frank Duveneck (1848–1919), accompanied by a dozen of his young American students in Munich, went on a trip to Venice. Whistler had been in the city for more than a year, seduced by its beauty and producing an extraordinary body of etchings that would prove influential, especially among American artists who embraced the revival of the "painterly" etching technique.

Whistler was born in Lowell, Massachusetts, and moved at the age of seven with his family to Russia; Tsar Nicholas I had invited his father, George Washington Whistler, a noted civil engineer and instructor at West Point, to supervise the building of the Saint Petersburg-Moscow railroad. Young Whistler enjoyed a relatively comfortable life in Saint Petersburg, where he took weekly drawing lessons with a private instructor; he later attended boarding school in England. At Christmas, the year he was fourteen, he announced that he had decided to become an artist. Although George Whistler had presented his son with Sir Joshua Reynolds's *Discourses*, he took a dim view of the youngster's decision. The elder Whistler's death the next year left James with no option

other than to fulfill his father's wishes and return to the United States and enroll at West Point. He remained there for three years, but did not complete his course of study.

In 1855, when he reached the age of twenty-one and came into a small legacy from his father, Whistler left for London (where his sister and her husband lived), intent on becoming an artist; he never returned to the United States. Although he did not renounce his citizenship, his position as America's most celebrated painter was earned entirely outside his home country.

In the 1870s, Whistler painted a series he called *Nocturnes*, lyrical studies of the intersection of sky and water in lambent moonlight. The watercolor *Blue and Silver* transposes the scene to a daylight view along the Thames. At the lower right is the artist's signature; originally, Whistler used his initials to form a butterfly cipher, which grew increasingly abstracted over the years, until it became the mark seen on this work. When he was a boy thinking of being an artist, his mother had advised him against such a flighty pursuit. "I only warn you not to be a butterfly sporting about from one temptation to idleness to another."[1] Perhaps choosing the butterfly as his seal and trademark was Whistler's way of pointing out the validity of his early decision.

1 As quoted in Katherine A. Lochnan, *The Etchings of James McNeill Whistler* (New Haven, Connecticut: Yale University Press, 1984), 7.

13

Blue and Silver
ca. 1890
Watercolor on paper
5 ⅜ × 8 ⅞ inches
Signed lower right: Artist's cipher
Clark Collection, 1958.4.5

WILLIAM STANLEY HASELTINE American, 1835–1900

Known in the 1860s for his quintessentially American paintings of the New England coastline, William Haseltine had by 1867 moved permanently to Europe. He had been in Europe before, studying in the 1850s in Düsseldorf alongside fellow Americans Albert Bierstadt (1830–1902) and T. Worthington Whittredge (1820–1910). It was the Düsseldorf style of robust draftsmanship and meticulous rendering that characterized Haseltine's painting style throughout his career. This view of the Church and Hermitage of Santa Maria a Cetrella on Capri's highest point, Monte Solaro,[1] appealed greatly to American collectors and typifies the works that Haseltine produced during his long sojourn in Europe.

Haseltine began studies in his native Philadelphia and continued at Harvard College, from which he graduated in 1854. He enjoyed early success, and by 1855 was exhibiting at the Pennsylvania Academy of the Fine Arts. With several years' study abroad to his credit, he returned to the United States and became known in the 1860s for a series of sixteen paintings of a rocky outcropping at Nahant in Massachusetts Bay. As early as the 1820s this small peninsula was serviced daily by steamboat from Boston; by the 1860s, Nahant had become a popular excursion for Bostonians seeking escape from the city. Haseltine's careful depiction of a recognizable site became a strategy that he often used.

The death of his first wife in childbirth in 1864 and his remarriage two years later may have prompted a return to Europe and a move to Rome in 1867. The Eternal City served for most of Haseltine's subsequent years in Europe as his home and point of departure for sketching trips throughout the continent. Rome had long been popular with American tourists, and post-Civil War prosperity provided the means for even middle-class Americans, like the feckless heroine of Henry James's 1878 novella, *Daisy Miller*, to travel abroad. An 1892 inventory of paintings in Haseltine's studio notes that several are destined for American collectors.[2]

Haseltine made his first visit to Capri in 1856, and returned in the springs of 1857 and 1858, when, according to his daughter and biographer, Helen Haseltine Plowden, he lodged at a local monastery.[3] In *Anacapri*, Haseltine lavishes attention on the rocks of the promontory in the foreground and the striking cactus plants that cover it. Tiny boats, mere specks in the water, emphasize the vertiginous height of the monastery.[4] The artist was influenced by the writings of John Ruskin and took to heart his urgings to artists to relay every rock and rill. Haseltine later wrote, "Every real artist is also a scientist."[5]

1 I am indebted to Carlotta Owens, Associate Curator, National Gallery of Art, Washington, D.C., for identifying this site, which is also the subject of a drawing by Haseltine recently acquired by the National Gallery.

2 Haseltine/Plowden Family Papers, as quoted in Marc Simpson, Andrea Henderson, and Sally Mills, *Expressions of Place: The Art of William Stanley Haseltine* (San Franciso: The Fine Arts Museums of San Francisco, 1992), 205.

3 It is tempting to think that this may have been the Church and Hermitage on Monte Solaro.

4 A watercolor of the same scene is titled *The Monastery*. Haseltine's attention to the historic architecture of Europe is another important feature of his paintings.

5 As quoted in Rebecca Bedell, *The Anatomy of Nature: Geology and American Landscape Painting, 1825–1975* (Princeton, New Jersey: Princeton University Press, 2001), 109.

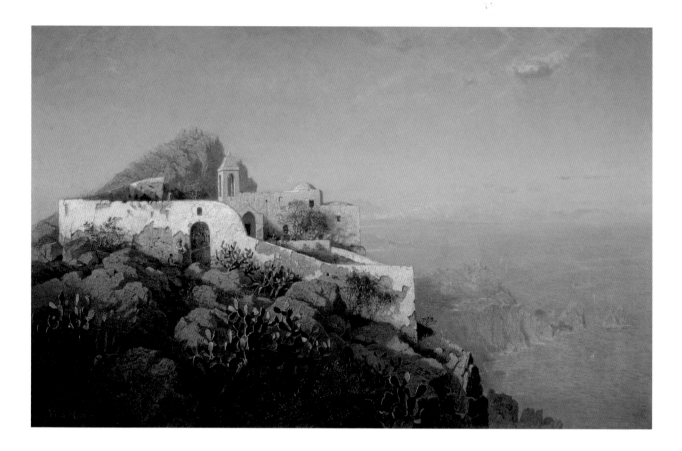

14

Anacapri
1892
Oil on canvas
22 ¾ × 36 ⅜ inches
Signed lower left: W. S. Haseltine. / Rome 1892
Littlejohn Collection, 1961.3.199

WILLIAM MERRITT CHASE American, 1849–1916

In 1891, two civic-minded Southampton, New York, residents had the idea of opening a summer art academy based on the *plein-air,* or out-of-doors, schools then popular in Europe. They invited the most renowned New York City teacher of the day, William Merritt Chase, to be the founding director of the Shinnecock Hills Summer School of Art. In subsequent summers (he taught there until 1902), students frequently asked their beloved teacher how they might find picturesque spots in the loamy countryside. Chase invariably responded that there was artistic gold in the dross of the scrubby Southampton hills, and proved it by painting lyrical summer landscapes that have come to be among the most beloved in American Impressionism.

Chase was always an astute marketer, anticipating fashions and trends. He had studied in the 1870s at the Royal Academy in Munich, and his early training with the leading realist painters of the day instilled in him a deep admiration for the work of the Old Masters, especially Velázquez and Hals. By the mid-1880s, American collectors were buying more French paintings than American; Chase took a cue from the Europeans and began to paint scenes in the newly established parks of Manhattan and Brooklyn, oases of respite and relaxation and social exchange for the urban populace.

The summer of 1891 was the first term of the Shinnecock school, and Chase, leaving his growing family in the city, took room and board at a local inn. One of his perquisites was a McKim, Mead, & White-designed house; the next summer, his entire family joined him there. A room specially fitted with north-facing windows served as a studio. The Shinnecock summers were the perfect inducement for Chase to experiment with brightening his palette for the ultimate expression of *plein-air* painting. His contemporary, the writer Henry James (1843–1916) articulated it this way: "Summer afternoon—summer afternoon; to me those have always been the two most beautiful words in the English language."[1]

1 Edith Wharton, *A Backward Glance.* (New York: Charles Scribner's Sons, 1934), 249.

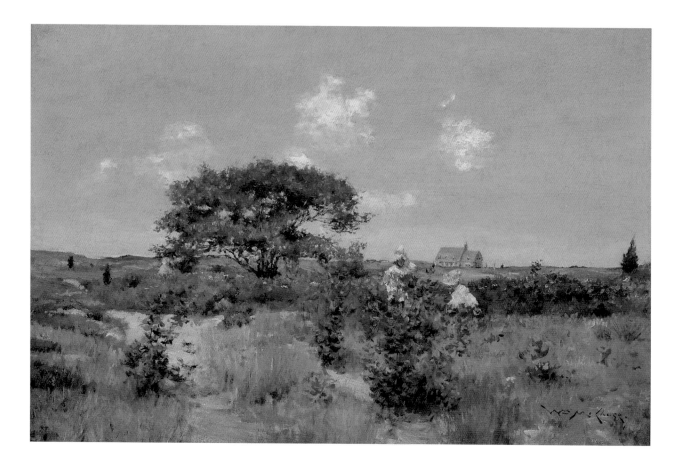

15

Shinnecock Landscape
ca. 1894
Oil on canvas
16 × 24 inches
Signed lower right: Wm. M. Chase
Museum Purchase, 1978.5

THEODORE ROBINSON American, 1852–1896

Giverny was a place of pilgrimage for Theodore Robinson, an American painter whose death at age forty-four cut short a promising career. After early training at the National Academy of Design in New York, he studied in Paris in the late 1870s at the atelier of the academic painter Jean-Léon Gérôme. By 1884, Robinson was spending most of the year in France. His admiration and respect for Claude Monet were steadfast, and a friendship with the older artist blossomed after Robinson's first summer sojourn at Giverny in 1887. Though informed by Impressionist technique and an evident interest in the effects of light and dark, Robinson's paintings never abandoned the structural integrity of form, the legacy of his academic training.

Moonlight, Giverny is one of several canvases that Robinson painted of the Giverny mill, the Moulin des Chennevières, at different times of day but from the same vantage point—a clear indication that he was influenced by Monet's serial approach. Using minimal compositional elements—the curving diagonal of the road; the uprights of the fence posts; the strong volumetric presence of the mill, heightened by the whitewashed walls that reflect the moonlight—Robinson has balanced the overall structure. The moonlit scene, unusual in his oeuvre, seems to have given him the courage to further the dissolution of line, the deepening of shadows, and the expressiveness of color.

In 1892, Robinson wrote an article on Monet for *The Century*, destined for an American audience fascinated by the French art colony and its most famous resident:

> Most painters have been struck by the charm of a sketch done from nature at a sitting, a charm coming from the oneness of effect, the instantaneousness seldom seen in the completed landscape, as understood by the studio landscape-painter. M. Claude Monet was the first to imagine the possibility of obtaining this truth and charm on a fair-sized canvas with qualities and drawing unattainable in the small sketch. He found it attainable by working with method at the same time of day and not too long, never for more than an hour.[1]

1 Theodore Robinson, "Claude Monet,"
 The Century, September 1892, 696.

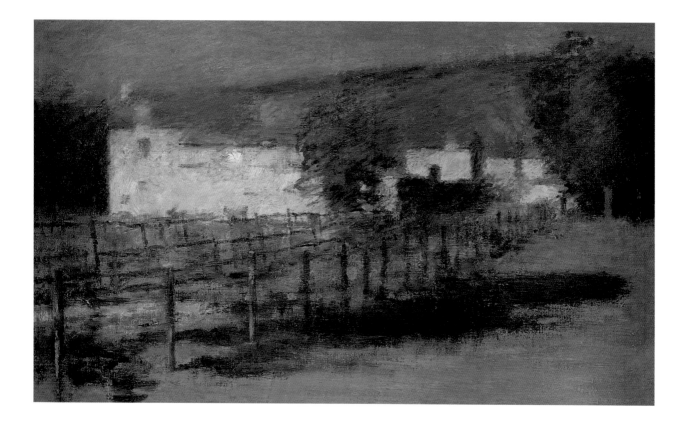

16

Moonlight, Giverny
ca. 1892
Oil on canvas
15 ⅝ × 25 ¾ inches
Gift of Rebecca Bolling Littlejohn, 1960.1.3

JOHN HENRY TWACHTMAN American, 1853–1902

John Henry Twachtman, like many of the artists who studied in Europe in the second half of the nineteenth century, brought back not so much a passion for French Impressionism's science of optical effects as a high regard for the naturalism of the French Barbizon school, whose leading artists Jean-Baptiste-Camille Corot (1796–1875) and Charles-François Daubigny (1817–1878) exhibited a marked fondness for *paysages intimes*, or intimate rural landscapes. It was less the vast grandeur of nature, beloved of the Hudson River School, and more the inherent poetics of landscape that appealed to Twachtman. In *Horseshoe Falls, Niagara*, he takes on as subject one of the preeminent sites of nineteenth-century American landscape painting, as natural phenomenon rather than as memorialized national icon.

Twachtman was born in Cincinnati and studied at the city's McMicken School of Design under the Munich-trained Frank Duveneck (1848–1919). The older artist took Twachtman under his wing, and the latter accompanied him when he returned to Munich in 1875. Twachtman studied at the Royal Academy there for three years and later at the Académie Julian in Paris.

He returned to the United States in 1885, and four years later moved with his wife and growing family to a farmhouse on seventeen lush acres with a stream and a pond in Greenwich, Connecticut. This new location anchored Twachtman over the coming decades and sustained the most prolific and successful years of his career.

Twachtman, who was well acquainted with Japanese art as both connoisseur and collector, was especially enthusiastic about an exhibition of Japanese prints he saw in the fall of 1893 at the Museum of Fine Arts in Boston.[1] In 1894 he visited the Buffalo physician and professor of anatomy Charles Cary and his wife, the artist Evelyn Rumsey Cary. During the winter and the summer, Twachtman painted fourteen views of nearby Niagara Falls. The paintings indicate a dialogue with Eastern aesthetic values. In *Horseshoe Falls*, the horizon line is pushed almost to the top; the falls themselves occupy the whole composition, virtually eclipsing the sky, rendered as a mere sliver of mist-laden atmosphere. If earlier artists dwelled on the iconic stature of the falls, for Twachtman they constitute a purely personal encounter.

1 Kathleen A. Pyne, "John Twachtman and the Therapeutic Landscape," in *John Twachtman: Connecticut Landscapes*, exhibition catalogue (Washington, D.C.: National Gallery of Art, 1990), 61.

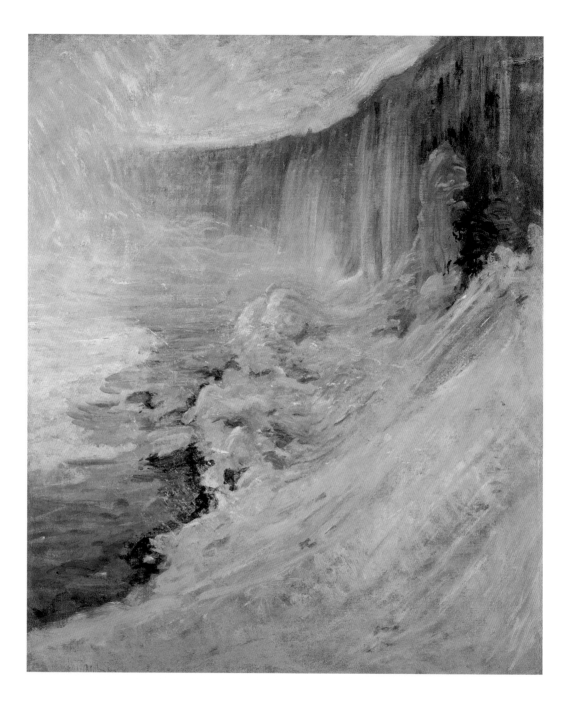

17

Horseshoe Falls, Niagara
ca. 1894
Oil on canvas
30 ½ × 25 ⅜ inches
Signed lower left: J H Twatchman
Gift of Rebecca Bolling Littlejohn, 1959.5.15

MARTIN JOHNSON HEADE American, 1819–1904

These two paintings date from the last years of Martin Johnson Heade's life, when, having married for the first time at age sixty-four, he was living in St. Augustine, Florida. As a young painter, Heade was influenced by the artist Frederic Edwin Church's (1826–1900) successful expedition to Brazil in the 1850s. Heade made a trip to Rio de Janeiro in 1863 and continued to travel extensively in South America and the Caribbean, including Colombia, Panama, and Jamaica. His sojourn in Florida marked a final period in his extended love affair with the flora and fauna of the tropics.

Heade was born to a farming family in rural Bucks County, Pennsylvania, where the folk artist Edward Hicks (1780–1849) was a neighbor and gave him his first art instruction. Heade started his career as an itinerant portrait painter in the United States and Europe. From 1859 to 1861 he rented space in the Tenth Street Studio Building in Manhattan. Opened in 1858, this new concept in facilities for the city's artists offered individual studio space and a well-lit exhibition room in which artists could display their work for prospective clients. From 1866 to 1879, Frederic Church shared his studio with Heade,[1] and the introduction to the glittering roster of artists working at the Studio Building hastened Heade's resolve to distinguish himself. He first became known for his paintings of intensely darkened storm clouds gathering on expanses of water, most famously on Narragansett Bay, and for dazzling depictions of the salt marshes along the Massachusetts coast. Heade avoided conventional dramatic effects in his landscapes, preferring to focus on the atmospheric play of light and water.

Long considered the "last frontier east of the Mississippi," Florida was entering a period of rapid development in the 1880s. Henry Morrison Flagler (1830–1913), a real-estate and railroad developer, was among those bent on transforming St. Augustine into the "Newport of the South." A founder of Standard Oil and one of the wealthiest men in the country, Flagler included artists' studios in his grand resort, the Hotel Ponce de León. Heade spent the last years of his life working there, catering to a clientele of vacationing northerners with luminescent images that conveyed the intense color and laden atmosphere of the tropical sunset.

1 Annette Blaugrund, *The Tenth Street Studio Building: Artist-Entrepreneurs from the Hudson River School to the American Impressionists* (Southampton, New York: Parrish Art Museum, 1997), 26.

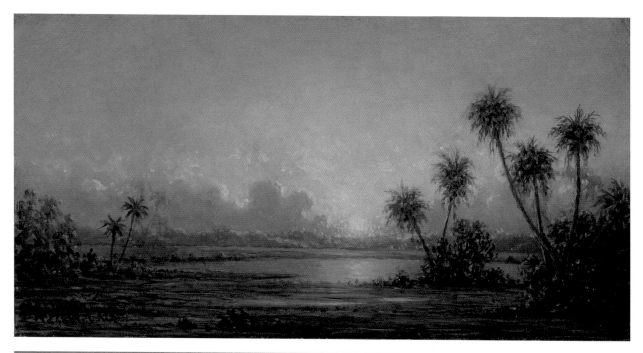

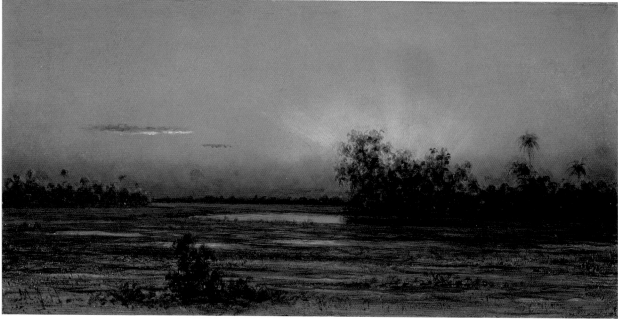

18

Florida Sunset, with Palm Trees
ca. 1895–1904
Oil on board
6 ⅛ × 12 inches
Signed lower left: M. J. Heade
Littlejohn Collection, 1961.3.54

19

Sunset: A Florida Marsh
ca. 1895–1904
Oil on board
6 ⅛ × 12 ⅜ inches
Signed lower left: M. J. Heade
Gift of Mr. and Mrs. Alfred Corning Clark, 1958.4.12

WILLIAM TROST RICHARDS American, 1833–1905

As a young painter, William Trost Richards looked to his artistic forebears in the first generation of the Hudson River School, such as Thomas Cole and Asher Durand. Born in Philadelphia, Richards had to give up his secondary education to go to work after the death of his father, and he became a designer for an ornamental metalwork firm. He later studied draftsmanship and painting in Philadelphia with the German-born landscape painter Paul Weber (1823–1916); a fellow student was William Stanley Haseltine. By 1852, Richards had exhibited at the Pennsylvania Academy of the Fine Arts, and in 1855 he set out on a European tour with Haseltine. Several months' study in Düsseldorf rounded out the excursion.

By June 1856, Richards was married and settled in Philadelphia. The carefully rendered studies that we know from his summer sketching trips suggest that the young artist had read Ruskin's *Modern Painters*, which had been published in New York in 1885. Richards is certain to have seen the exhibition of English art, much of it by Pre-Raphaelite painters and followers of Ruskin, held at the Pennsylvania Academy in 1858, the year Richards began to paint out-of-doors. He took to heart Ruskin's admonition to "'paint the leaves as they grow!' If you can paint one leaf, you can paint the world."[1]

In 1863, Richards was elected to the newly formed Association for the Advancement of Truth in Art, founded to promote Ruskinian principles among American painters. By the late 1860s, he was spending summers along the eastern seaboard; after 1874, he stayed in Newport, Rhode Island. In 1884 he built a house there, Gray Cliff, that featured a panoramic view of the bay and ocean. Richards made his own mark as a recorder of marine scenes. Standing in the water, he painted quick sketches that served as source material for his studio paintings. He was particularly interested in capturing the effects of light on water, waves crashing on rocks, and the ocean in a diffusing haze of mist.

1 John Ruskin, *Modern Painters*, Vol. V, part VI, "Of Leaf Beauty" (New York: John Wiley & Sons, 1885), 35.

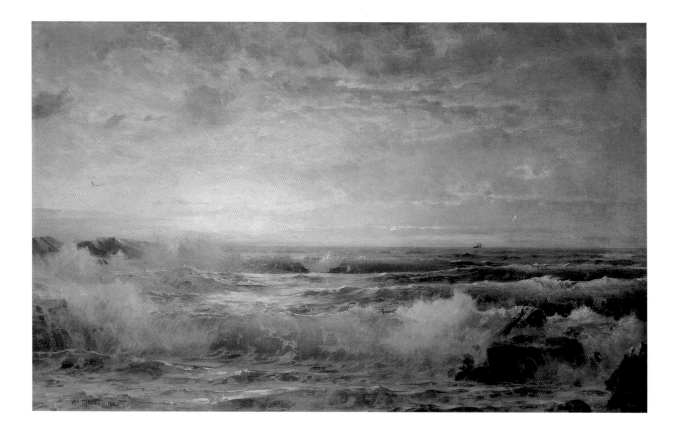

20

Untitled (Seascape)
1901
Oil on canvas
20 × 32 ¼ inches
Signed lower left: Wm. T. Richards. 1901.
Gift of Paul J. Liehr, In Memory of Joseph H. Liehr, 1979.6

EDITH MITCHILL PRELLWITZ American, 1864–1944

As a young woman, Edith Mitchill was determined to study art and began taking classes at the Art Students League in New York. Raised in a cultured family in South Orange, New Jersey, she had visited Europe by the time she was eighteen. In 1887, at the suggestion of her teacher George de Forest Brush (1855-1941), she had the temerity to enroll in the League's Life Class, where nude models were used—a bold step for a young female artist in those days, and one that determined her course as a serious professional. During her years at the League, between 1883 and 1889, she studied with Brush, William Merritt Chase, Walter Shirlaw (1838-1909), and Kenyon Cox (1856-1919), all noted artists. In 1889 she went to Paris, where she studied at the Académie Julian under William-Adolphe Bouguereau (1825-1905).

Upon her return to New York, Mitchill established a New York studio and became reacquainted with a fellow painter, Henry Prellwitz, who had attended classes at the League at the time she was there and who had also been studying in France, although their paths seem not to have crossed there. They were married in 1894 and first summered in the artists' colony in Cornish, New Hampshire, and built a cottage there in 1895. When it was destroyed four years later by fire, they began spending summers in Peconic, Long Island, attracted by friends and fellow artists Irving Ramsey Wiles and Edward August Bell. In 1911, the couple acquired an early nineteenth-century house on Peconic Bay, which became their year-round residence three years later.

The picturesque tidal inlets that dot the North Fork of Long Island offered ample subject matter for Prellwitz. She was known for her portraits of women and children and for her depictions of allegorical figures, but she also relished the opportunity to explore the pastoral beauty of the North Fork.

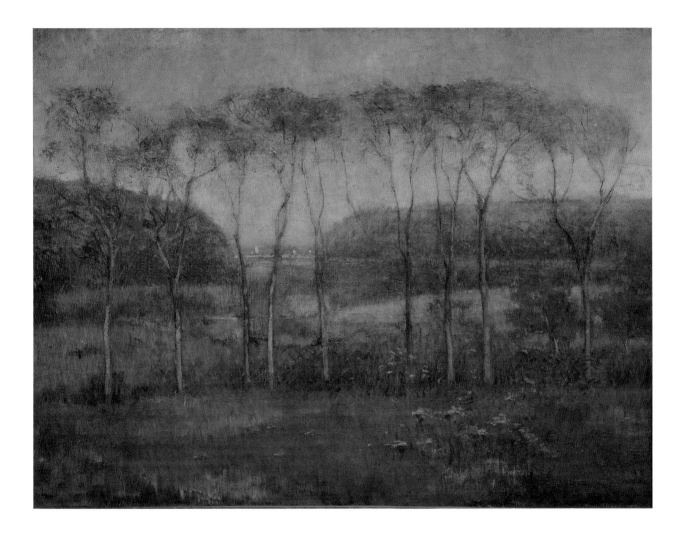

21

Entrance to Peconic
1902
Oil on canvas
27 × 36 inches
Signed lower right: E. P. 1902
Gift of Stéphane Samuel and Robert M. Rubin, 2004.13.4

FREDERICK CHILDE HASSAM American, 1859–1935

The centennial of American independence in 1876 set in motion an ongoing quest for what has been called a "usable past." *Church at Old Lyme* expresses a yearning for a bygone era and signals Frederick Childe Hassam's abiding interest in the trappings of the American colonial past. Beginning in the mid-1890s, Hassam spent summers in various art colonies along the Atlantic coast, including the Isles of Shoals, a cluster of rocky islands off the New Hampshire coast, and Cos Cob and Old Lyme in Connecticut. He finally settled in East Hampton, where he became a year-round resident in 1919. From the cliffs and seaside gardens of Appledore, in the Isles of Shoals, to the villages of the Connecticut shore and eastern Long Island, he sought out surroundings that offered an antidote to modernity, where change and instability could be, if not avoided, at least temporarily forgotten.

Hassam began his career as an illustrator in his native Boston. A trip to Europe in the summer of 1883 motivated him to pursue landscape painting. He married the next year, and in 1886 embarked with his wife on an extended sojourn in France. He found his studies at the Académie Julian, in the ateliers of Gustave Boulanger (1824–1890) and Jules Lefebvre (1836–1911), to be stifling, and remained somewhat aloof from his fellow artists, both French and American, in Paris. He was, nonetheless, very aware of their brightened palette and loose handling of the brush, and of the popularity of city scenes in their work. Hassam's production was well received by critics, and sales through his Boston gallery enabled him to

continue his stay in Paris. He and his wife returned to the United States at the end of 1889, relocating to New York. Hassam was poised to become a leading figure among American artists influenced by progressive trends from Europe, including William Merritt Chase, John Henry Twachtman, and J. Alden Weir.

Hassam first visited Old Lyme in 1903 and stayed at the boardinghouse of Florence Griswold, who furnished visiting artists not only with room and board but with studio space as well. In addition, she offered her walls as a provisional gallery. Hassam depicted Old Lyme's most famous edifice, the First Congregational Church, seven times, in oil, pastel and etching. In the three versions in oil (dated 1903, 1905, and this one, 1906), the angle on the church shifts in a 180-degree arc, as though the building were a grande dame proffering her best side for a portrait.

To Hassam, the Connecticut village was emblematic of America's rich heritage. His close-up views of the white church steeple, set against dazzlingly clear blue skies and encircled by native elms (symbolic of the nation's strength), became the stuff of picture postcards. Hassam often spoke of his New England roots and made no secret of his dismay at the increasing waves of immigration, which he felt diluted the dominance of the United States' historically Anglo-Saxon majority.

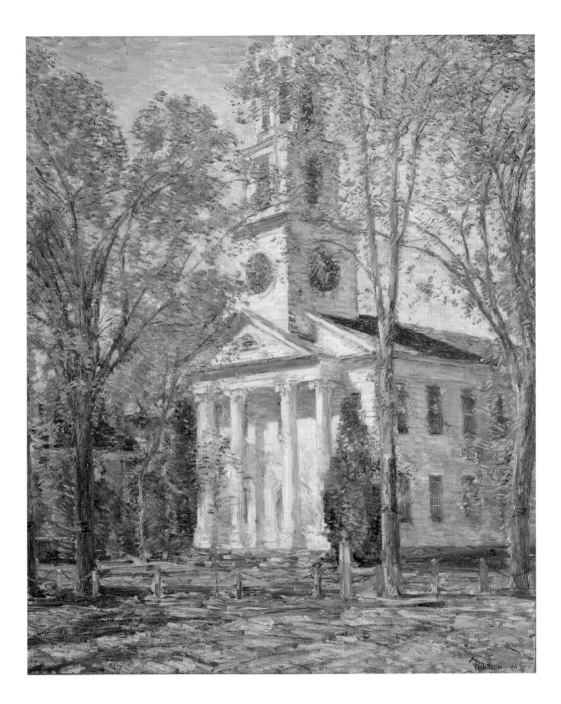

22

Church at Old Lyme
1906
Oil on canvas
30 ⅛ × 25 ¼ inches
Signed lower right: Childe Hassam 1906
Littlejohn Collection, 1961.3.131

IRVING RAMSEY WILES American, 1861–1948

Irving Ramsey Wiles first studied art with his father, the painter and pedagogue Lemuel Maynard Wiles (1826–1905), and taught alongside him at the Silver Lake Art School, which the elder Wiles had founded, near Perry, New York, southwest of Geneseo. The younger Wiles's formal instruction began at the Art Students League, where he took classes from 1879 to 1881, studying with J. Carroll Beckwith (1852–1917) and, perhaps most significantly, with William Merritt Chase (1849–1916). Wiles traveled abroad for further study, notably in Paris at the atelier of Beckwith's teacher, Charles-Auguste-Émile Duran, known as Carolus-Duran (1838–1917).

Observing the success of the summer art school that Chase began in Southampton's Shinnecock Hills in 1891, Wiles launched his own school and around 1895 began teaching summer classes in Peconic, on Long Island's North Fork. Though far less developed than the South Fork, the North Fork had been made accessible by railroad as early as the 1840s, when a line to Greenport was completed, an ultimately unsuccessful scheme to make a train ride from New York to Greenport and then a ferry to Boston the quickest and most desirable route between the two major cities.

Wiles built a home in Peconic, The Moorings, that sat high on a bluff overlooking the bay. An accomplished sailor, he was also fascinated by the active fishing industry on the North Fork, especially the boats that plied the bay dredging for scallops. As many as two hundred vessels might be engaged in this enterprise in any one season. Rough weather often meant the best time to harvest, since churned-up waters meant agitated scallop beds that sent the bivalves roiling. And the greater the wind gusts, the faster and deeper the boats were able to dredge.

The overcast and blustery day depicted in *Scallop Boats, Peconic* is not only perfect for scallop-dredging but for Wiles's artistic purposes as well. The painting has the immediacy of a sketch, and Wiles presents the scudding clouds, ballooning sails, and choppy waves with a minimum of facture. The high horizon line compresses the energy in the painting.

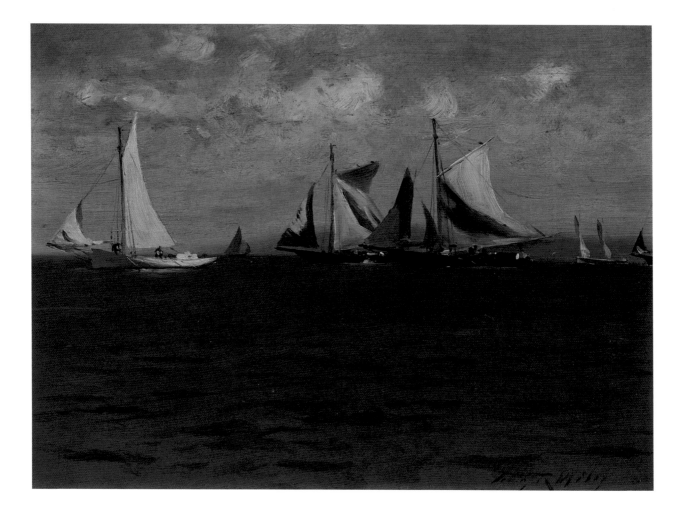

23

Scallop Boats, Peconic
ca. 1910
Oil on wood panel
9 ½ × 13 inches
Signed lower right: Irving R. Wiles
Museum Purchase, 1980.17

HENRY PRELLWITZ American, 1865–1940

In the late 1890s, Henry Prellwitz and his wife, the painter Edith Mitchill Prellwitz, began visiting eastern Long Island and the less populous North Fork. By 1914, they had decided to live year-round in Peconic, and Henry painted the local landscape during the winter. There is an evident affinity in his winter images with what the French Impressionists called *effets de neige*. Prellwitz had made several extended visits to Giverny while studying in France in the late 1880s, one in the winter months. John Henry Twachtman expressed what many American artists aligning themselves with the French Impressionists felt when he wrote to fellow artist J. Alden Weir in 1891: "We must have snow and lots of it. Never is nature more lovely than when it is snowing. Everything is so quiet and the whole earth seems wrapped in a mantle."[1]

Prellwitz was born in New York City in 1865 and studied at the Art Students League under Thomas W. Dewing in the mid-1880s. He went to Paris in 1887 and attended classes at the Académie Julian. During his visits to Giverny, he absorbed the lessons of *plein-air* painting. He returned to New York and established a studio, and shortly thereafter met Edith Mitchill. They married in 1894. The Prellwitzes enjoyed the camaraderie and friendship of artist neighbors Irving Ramsey Wiles and Edward August Bell and their families. In 1911, the Prellwitzes purchased an early nineteenth-century house, which they moved to land they owned on Indian Neck, a promontory jutting into Peconic Bay. Adjoining studios were built, and the two artists spent many happy years in this idyllic setting.

1 As quoted in Linda Merrill, *After Whistler: The Artist and His Influence on American Painting* (Atlanta: High Museum of Art, 2003), 234.

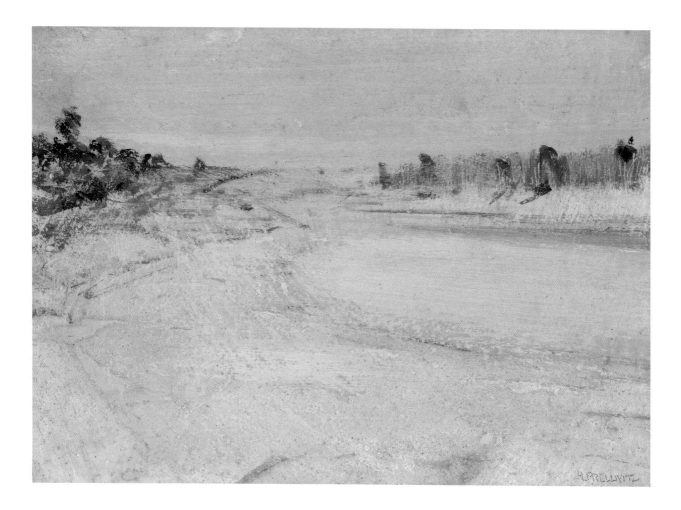

24

Frozen Creek
ca. 1914
Oil on board
8 × 11 inches
Signed lower right: H. PRELLWITZ
Gift of the Prellwitz Family and Spanierman Gallery, New York,
2009.11

ERNEST LAWSON American, b. Canada, 1873–1939

Born in Nova Scotia, the son of a physician, Ernest Lawson studied and traveled extensively before arriving in New York in 1891 to enroll at the Art Students League, where his teachers were John Twachtman and J. Alden Weir. He followed Twachtman to his summer school in Cos Cob, Connecticut, to study *plein-air* painting. Even after Lawson's association with the artist group The Eight—most of whom were known for their gritty depiction of urban life—he retained his vital interest in landscape studies.

Like most young American artists of his day, Lawson was aware of the French Impressionists. During a stay in Paris in 1893, he met the painter Alfred Sisley (1839–1899), who was of English parentage but had been born and raised in France. Lawson developed his own highly individual style of thickly applied brushstrokes that built up a flickering and highly active surface—a style that connected his work more closely with that of the Post-Impressionists.

Despite his exclusive choice of the fairly conservative subject of landscape, Lawson held many progressive views. Along with the independent artists Arthur B. Davies and Maurice Prendergast, he joined five realist painters—Robert Henri, William Glackens, George Luks, Everett Shinn, and John Sloan (members of the Ashcan School)—to form The Eight. They exhibited together only once, at New York's Macbeth Gallery in February 1908. Lawson helped organize and contributed to the 1913 International Exhibition of Modern Art, better known as the Armory Show.

In *Summer Landscape, Connecticut*, Lawson has pushed the horizon line almost to the top of the painting. He frequently used the device of a scrim of trees in the foreground. Whether the trees are leafless or in full summer foliage, as seen here, linearity is emphasized. Paint, thickly applied in short, percussive strokes, gives a tactile quality to the surface. In 1912, when the emerging collector Duncan Phillips purchased his first painting, he chose Lawson's *High Bridge—Early Moon* (1910).

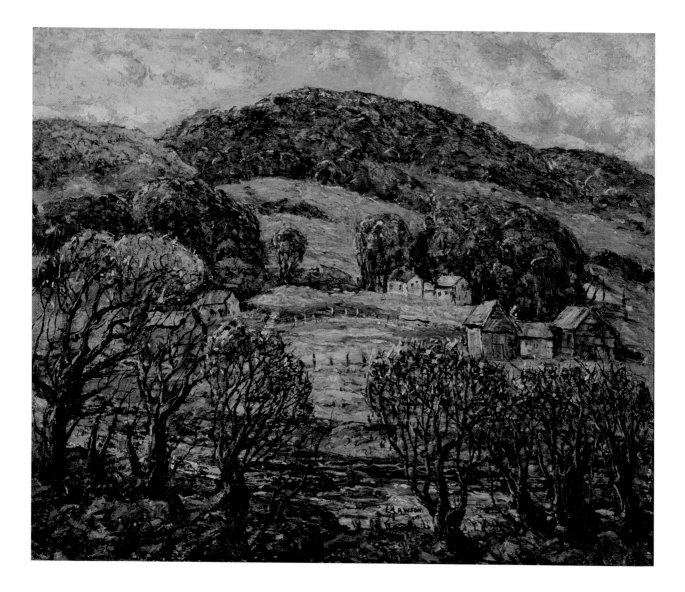

25

Summer Landscape, Connecticut
ca. 1915
Oil on canvas
25 ¼ × 30 ¼ inches
Signed lower center: E. LAWSON.
Clark Collection, 1959.6.19

JOHN FRANCIS MURPHY American, 1853–1921

As a young man, John Francis Murphy set out from his home in upstate New York determined to broaden his horizons. One of the first jobs he took was as a billboard painter in Chicago. By 1875 he had returned East and established a studio in New York City, and the next year was exhibiting at the National Academy of Design. Murphy, who based his work on the direct observation of nature, was by the mid-1880s able to build a studio in the Catskills at Arkville, where he spent summer and fall, retreating to a winter studio in New York City only after the weather became severe. His reputation in the 1880s and 1890s was built on paintings in the popular Barbizon mode; he was sometimes compared to Corot.

By 1900, Murphy's landscapes were characteristically imbued with the prevailing colors of autumn. *Indian Summer*—a theme to which he returned again and again—shows his nuanced color harmonies and the modernity of a composition based on closely related tonal values. The phrase "Indian summer" refers, of course, to the period in late autumn when an unusual spate of warm weather comes after the first frost—a reprieve from the oncoming winter made all the more poignant by its transitory nature.

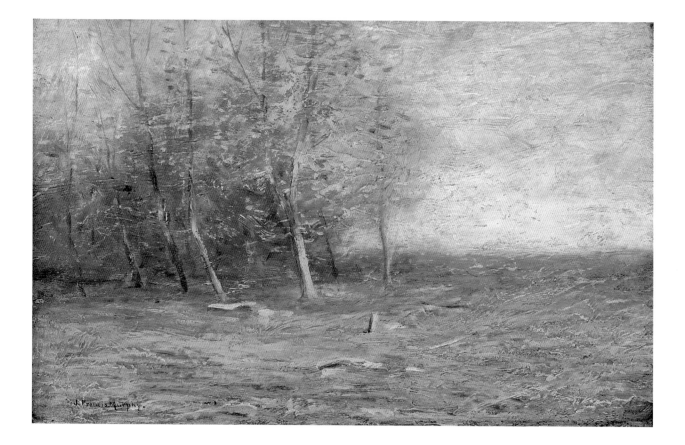

26

Indian Summer
ca. 1915
Oil on wood panel
11 ¼ × 17 ½ inches
Signed lower left: J. Francis Murphy.
Littlejohn Collection, 1961.3.5

JOHN MARIN American, 1870–1953

Around 1916, John Marin began a series in Weehawken, New Jersey, of nearly a hundred small paintings on canvas board that were radical in subject matter and execution. Instead of producing finished surfaces, he used oil paint to improvise quick landscape sketches of the barren late-fall views from the Jersey side of the Hudson River, looking toward midtown Manhattan. The paintings were not exhibited publicly, and were virtually forgotten by the artist until they were discovered in storage in 1947. The Weehawken series remains a seminal experiment in the annals of American abstraction.

Marin was born in Rutherford, New Jersey, and raised in Weehawken by two maiden aunts after his mother's death. He studied mechanical engineering (he was briefly enrolled at the Stevens Institute of Technology) and pursued a career in architecture before entering the Pennsylvania Academy of the Fine Arts in 1899 to study painting. There, he took courses with Thomas Anshutz (1851–1912), among others. After a year at the Art Students League in New York, Marin left for Paris in 1905 and studied for a short time at the Académie Julian. During a five-year sojourn in France, he produced an estimable body of works on paper, including pastels, watercolors, and etchings, Whistlerian in tone and promising in execution. These came to the attention of another young American in Paris, the painter and photographer Edward Steichen (1879–1973), who was functioning as something of a talent scout for the New York gallery owner and photographer Alfred Stieglitz (1864–1946). Such was

Steichen's enthusiasm upon visiting Marin's Paris studio in 1909 that he sent a group of watercolors to New York to be included in a spring exhibition at Stieglitz's Little Galleries of the Photo-Secession, known as 291 for the address on Fifth Avenue.[1] Stieglitz himself paid a visit to Marin's Paris studio in June of that year and organized the first one-man show of Marin's work at his gallery the following February.

The years in Paris exposed Marin to the many facets of European modernism, including Cézanne, the Fauves, Cubism, and Kandinsky. He returned to the United States for good in 1910, buoyed by the continued support of Stieglitz and confident that modernism had a secure home in America. In the Weehawken series, we see the efflorescence of these European influences in the boldness and self-assurance of Marin's approach. In *Weehawken Sequence* there is little visible build-up of paint; each color is laid down in strokes that remain distinct. Trees are delineated with staccato brushwork, vegetation in whorls of color, and background buildings are blocked out in solid rectangles. Although this experiment did not lead to further dissolution of form, Marin was obviously testing his mettle with these canvases.

1 *Exhibition of Sketches in Oil by Alfred Maurer, of Paris and New York; and Water-Colors by John Marin, of Paris and New York*, exhibition brochure; the exhibition was held from March 30 to April 19, 1909.

27

Weehawken Sequence
ca. 1916
Oil on canvas board
10 × 12 ½ inches
Gift of Norma B. Marin, 1994.1

JOHN SLOAN American, 1871–1951

John Sloan's vibrant depictions of everyday life won him great acclaim. A student of Robert Henri, he started his career in newspaper illustration, and this rapid and spontaneous style informed his later paintings. In *Gist of Art* (1939), his autobiographical compendium of teaching philosophy and technical advice, Sloan describes the lively summer scene glimpsed in this work, painted on the Massachusetts coast at Cape Ann: "Down this picturesque dip into town rolls a blue Mercedes, a few years old but full of pep and power. The driver is Randall Davey who painted in Gloucester several summers. The picture is rich in tone and was painted on the spot."[1]

Sloan and his wife shared a cottage with friends in Gloucester in 1914 and returned every summer through 1918. This was their first season spent away from the heat and clamor of the city, and Sloan's first extended experience of painting outdoors. "Instead of imitating the colors in nature," he said, "I decided on some quality of color that interested me and set a limited palette."[2] The charming seaside resort proved to be as inspiring as the gritty urban setting. He produced nearly three hundred canvases in his five summers in Gloucester, more than he had done in the preceding twenty-four years of his career.

The bustle of daily life was for Sloan an abiding interest. Many artists would have chosen a more picturesque prospect in this charming New England fishing village with its busy wharf and colonial-era shingled houses. In Sloan's view, two women walk briskly up the hill, their heads inclined toward each other, suggesting that they are deep in conversation. A flock of pigeons scatters as a motor car rapidly descends the hill. A horse-drawn wagon is just reaching the crest, separated from the car by trolley tracks; the trolley itself sits at the base of the hill. Electric poles line the street. For Sloan, the vivid details of modern life were a rich and worthy subject to paint.

1 As quoted in Lloyd Goodrich, *John Sloan* (New York: Whitney Museum of American Art, 1952), 50.

2 John Sloan, *Gist of Art* (New York: American Artists Group, 1939), 249.

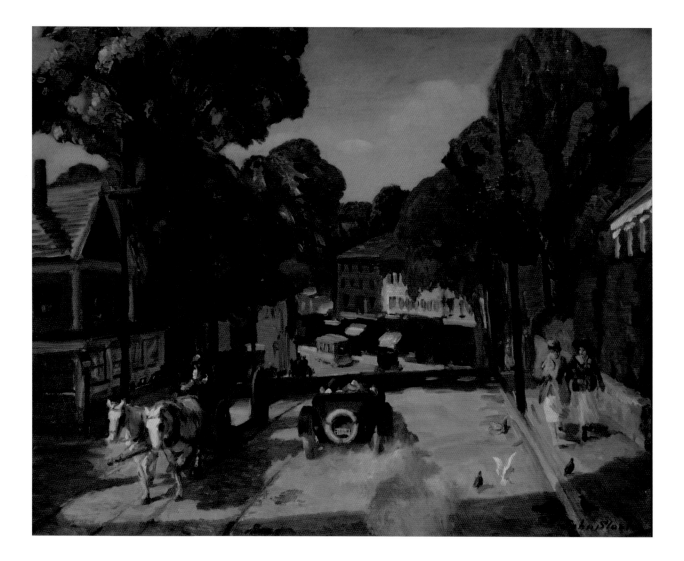

28

Hill, Main Street, Gloucester
ca. 1916
Oil on canvas
25 ¾ × 39 ⅞ inches
Signed lower right: John Sloan.
Littlejohn Collection, 1961.3.208

ROBERT HENRI American, 1865–1929

A charismatic teacher and co-founder of the group known as The Eight, Robert Henri was one of the most influential painters of his day. As a young man he studied with Thomas Anshutz (1851–1912) and Thomas Hovenden (1840–1895) at the Pennsylvania Academy of the Fine Arts; later he studied in Paris, and settled in New York City by 1900. Noted for his sympathetic portraits, Henri was less recognized for his landscapes, although he had firmly held views about the genre. As he wrote in *The Art Spirit* (1923), "Landscape is a medium for ideas. We want men's thoughts. . .and so the various details in a landscape painting mean nothing to us if they do not express some mood of nature as felt by the artist."[1]

Henri spent September and October of 1918, the waning days of World War I, on Monhegan Island, Maine. He had traveled there sporadically before, first visiting in 1903 with his wife, Linda. Their initial experience of the island was so successful that Henri, who was then teaching at Chase's Shinnecock Hills Summer School of Art on Long Island, resolved to return to Monhegan and establish his own summer art school. He did not, in fact, return until 1911, by which time Linda, long in poor health, had died.

The summer of 1918 found Henri and his second wife, Marjorie, stranded in New York City. Poor sales had compelled him to forgo a seasonal rental, but by September they were able to secure reasonable living quarters on Monhegan, which was practically deserted because of the number of reports of enemy submarines along the coast. Working mostly in pastel and mostly out-of-doors, Henri produced at least one hundred drawings, astonishing in choice of subject matter and freedom of execution. Instead of the rocky coastline that he had often depicted, he turned to the dense woods in the interior of the island. He laid down pastel in dark, rich jewel tones to evoke the depth of the undergrowth, and dazzling white to highlight the verticals of the birch trunks and the distinctive rock formations. The high-keyed foreground conveys the changing colors of the season. For this work, Henri selected a fittingly poetic title that emphasizes his connection to the island as a place of solitude and solace.

1 Robert Henri, *The Art Spirit* (Philadelphia, London, J. B. Lippincott Company, 1923), 84.

29

At the Place of the Three Trees
1918
Pastel on paper
20 ⅛ × 27 ⅝ inches
Signed lower right: R Henri
Museum Purchase, Friends of the Collection Fund, 1987.6

GUY PÈNE DU BOIS American, 1884–1958

Guy Pène du Bois is perhaps best known for his keenly satirical observations of café society in 1920s and 1930s New York and Paris. He studied with William Merritt Chase at the New York School of Art in 1899, and subsequently took courses with Robert Henri when the latter joined the school's staff in 1902. The influence of these preeminent teachers is evident in Pène du Bois's facility with the figure. He also took to heart Henri's exhortation to paint from real life. Pène du Bois's distinctive figure style carried over into his less well-known landscape painting.

Born in Brooklyn, the descendant of French immigrants who settled in Louisiana in the early eighteenth century, Pène du Bois made his first trip to Paris in 1905. Once he returned to the United States, he wrote art criticism to supplement his income, and he seems always to have been at the center of the modern art movement. After the first exhibition of The Eight at the Macbeth Gallery in New York in 1908, John Sloan noted: "They report a great crowd at the gallery and young du Bois, the artist and critic of *The American*, came in most enthusiastic over the show. He wants photos for the article."[1]

From 1920 to 1924 he lived with his wife and young family in Westport, Connecticut, a fashionable suburb that attracted writers including F. Scott Fitzgerald and Sherwood Anderson. There Pène du Bois was able to observe the frenetic gaiety of the Prohibition era and the rise of the flapper. His acute observations captured social stereotypes and held them up to the light. In 1924, Pène du Bois moved to Paris, securing a reasonable rent in a village some thirty miles from the city. The paintings he made there were rapidly sold through his New York dealer, and thus he was able to remain abroad until the stock market crash in 1929, when he and his family had to return to the United States.

Pène du Bois took up teaching upon his return, and in 1932 established a summer school of art in Stonington, Connecticut, where he held classes for more than twenty years. While he is not recognized for landscape painting, he obviously relished the opportunity that the summer sessions gave him to paint the countryside. In *Farm Landscape*, the rounded shape of the foreground bushes and the trees dotting the terrain recalls the contours of Pène du Bois's human figures.

1 As quoted in Bruce St. John, *John Sloan* (New York: Praeger, 1971), 33.

30

Farm Landscape
1934
Oil on canvas
20 × 25 inches
Signed lower left: Guy Pène du Bois 34
Gift of Albert P. Loening, Jr., 1989.9.1

GRANDMA MOSES [ANNA MARY ROBERTSON] American, 1860–1961

"I had always wanted to paint," Grandma Moses quipped in 1943, "but I just didn't have time until I was seventy-six." Anna Mary Robertson's hardscrabble life as a hired girl and later a farmwife in upstate New York afforded her little opportunity to explore her creative instincts beyond household sewing. When she was in her early seventies, one of her daughters suggested she might enjoy "thread painting," or embroidered pictures, and when her hands became too arthritic for this detailed work, she took up paint and brushes. Apparently never at a loss for inspiration, Grandma Moses painted more than 1,500 pictures from 1935 until 1961, the year of her death.[1] Although she repeated popular scenes (the boy with the hatchet chasing the Thanksgiving turkey, for example), her devices were not formulaic and each work presents fresh, distinctive elements. Foregrounds are typically detailed, buzzing with human activity. Winding roads and receding mountains often draw the eye to a panoramic backdrop. Facial features rarely exceed two cursory black dots and a sweep of line for a smile.

Not surprisingly, Grandma Moses painted what she knew, and much of her imagery centers on the seasonal cycles of work and holidays, planting and harvest, that were the natural sequence of life on the farm. She said that the idea for her panoramic vision came to her in a flash—when she saw the familiar countryside reflected in the hubcap of a car.

Robertson was discovered when a New York collector happened to stop in a drugstore in her hometown, Hoosick Falls, New York, where several of her works were included in a women's exchange display. Her work was soon caught up in the avant-garde's enthusiasm for the "primitive," spearheaded by Alfred H. Barr, Jr., founding director of the Museum of Modern Art in New York. It was included in the museum's 1939 exhibition *Contemporary Unknown American Painters*.

Throughout the Depression, the war years, and 1950s Cold War America, her homespun vision—in paintings such as *Sugaring Off* (1943), *Over the River to Grandma's House on Thanksgiving Day* (1947), *White Christmas* (1954), and *Haying* (1956)—evinced a nostalgia for how things used to be. Her images remain as comforting now as they were in the 1930s, and her popularity endures.

1 Lee Kogan, *Grandma Moses: Grandmother to the Nation* (Cooperstown, New York: Fenimore Art Museum and New York State Historical Association, 2007), 32.

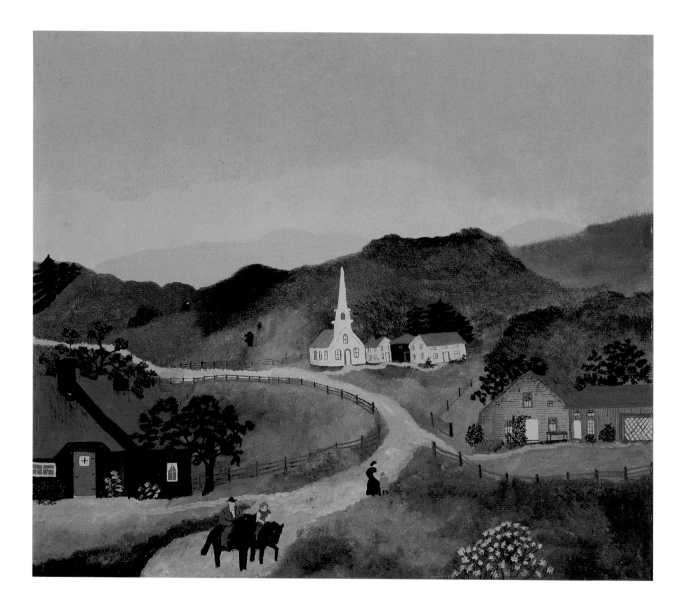

31

Church Among the Hills
1944
Oil on Masonite
20 ⅝ × 24 inches
Signed lower right: Moses.
Gift of Dr. Otto Kallir, 1961.6

NICOLAI CIKOVSKY American, b. Belarus, formerly Russia, 1894–1984

In 1942, Nicolai Cikovsky and his wife started visiting the East End of Long Island, staying at a small cottage on North Sea's Wooley Pond, near the village of Southampton. His imagery changed markedly in response to his new surroundings, the social content of his Depression-era canvases giving way to painterly representations of particular sites on the South Fork.

Cikovsky was born in Minsk, a city then in Russia near the Polish border, and began his study of art as a teenager at the Vilna (Vilnius) Art School, where Chaim Soutine also studied. Cikovsky went on to the Penza Art School, and then the Higher Art and Technical Workshops (Vkhutemas) in Moscow. His life was disrupted when Minsk became a western battlefront in World War I; the upheaval of the Bolshevik Revolution forced him to immigrate to the United States in 1923. Fully immersed in Cubism, Expressionism, and above all the works of Matisse, he rebuilt his career in New York City. By the time Cikovsky moved to North Sea, he had discovered a group of artists who shared his immigrant background, notably the Ukrainian-born David Burliuk (1882-1967), who settled in the neighboring village of Hampton Bays, as well as George Constant (1892-1978), Michael Lekakis (1907-1998), and Theo Hios (1910-1998), all of Greek descent and residents of Southampton.

Cikovsky once wrote that "spectacular or sensational elements do not interest me, preferring as I do intimate subjects that I see and have contact with in everyday life—fishing houses, gardens, ponds, city squares, parks and streets."[1] This sentiment is apparent in *The Inlet to Wooley Pond*, which depicts a location just across the road from the artist's house. A brisk wind, suggested by the flecks of paint that animate the surface of the water, has come up on the brackish pond that empties into Little Peconic Bay. Clouds scud across the sky, and the tall grasses on the sandy bank in the left foreground bend sharply in the stiff wind. A fisherman in a small rowboat in the inlet is pinned against the shore, his tautly inclined body demonstrating that an incoming tide exerts considerable force as well. Cikovsky has merged close observation with unifying formal devices to achieve a painting more subtly complex than its straightforward subject suggests.

1 *Nicolai Cikovsky: Oil Paintings*, exhibition brochure (New York: Associated American Artists Galleries, 1952), n.p.

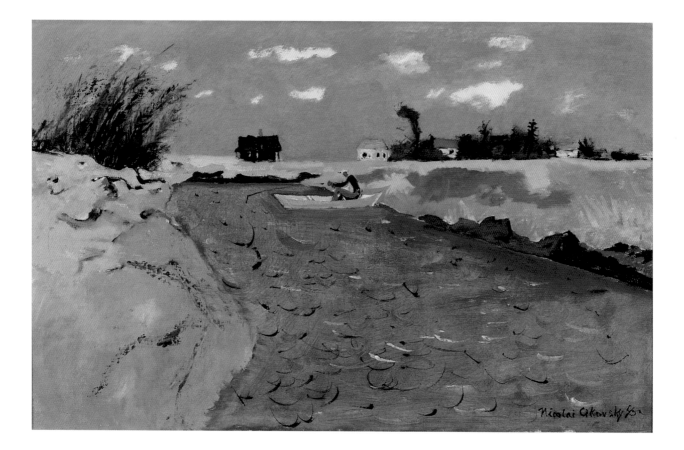

32

The Inlet to Wooley Pond
1945
Oil on canvas
18 × 28 ⅛ inches
Signed lower right: Nicolai Cikovsky 45
Gift of D. Frederick Baker,
from the Baker-Pisano Collection, 1977.9

JOHN MARIN American, 1870–1953

Best known for his watercolors, John Marin was a painter who also revered the viscosity of oil paint and the possibilities inherent in the medium. His early education was in engineering, and he worked as an architect before enrolling at the Pennsylvania Academy of the Fine Arts in 1899 to study painting. Perhaps because of his early background he frequently spoke of "building the picture."

Marin first summered in Maine in 1914, and with few exceptions he would spend a good portion of the year there for the rest of his life. The water surrounding his house on Cape Split and the landscape inland, especially the nearby Tunk Mountains, also afforded endless inspiration. Plain-spoken and unpretentious, the artist became forever associated with the image of the New England Yankee. By the 1940s he was regarded as the quintessentially American artist.

In this view of the Tunk Mountains, part of an extended series, Marin never abandons a direct observation of nature, yet the landscape is faceted into distinct planes that animate the surface. The consistency of the oil paint is varied: sometimes the brush is loaded and thick flecks of impasto materialize; elsewhere the paint is a thinned black line drawn on the surface of the bare canvas. Marin's connection to his subject was concrete. In an interview conducted the year after he made this painting, he described his approach: "When I'm up against a mountain. . .I don't say I can paint it, but ask 'Mountain, will you allow me to look at you?'"[1]

1 As quoted in Ruth E. Fine, "John Marin: An Art Fully Resolved," in Sarah Greenough, *Modern Art and America: Alfred Stieglitz and His New York Galleries* (Washington, D.C.: National Gallery of Art, 2000), 352.

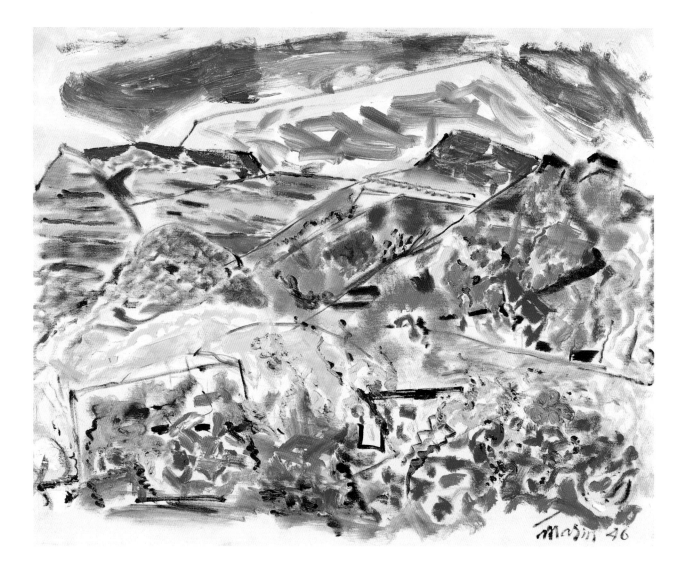

33

Tunk Mountains, Maine
1946
Oil on canvas
24 ⅞ × 32 inches
Signed lower right: Marin 46
Museum Purchase, Robert Lehman Fund, 1984.1

CHARLES BURCHFIELD American, 1893–1967

For most of his life, Charles Burchfield lived in Gardenville, New York, a suburb of Buffalo to which he and his wife moved in 1925, raising a family of five children. Although the artist seldom ventured far from home in his quest for subject matter, his work transcends regionalist labels. Possessed by an intense, quasi-mystical response to nature, throughout his life Burchfield recorded his thoughts in journal entries that he started writing as a teenager (they total more than 10,000 handwritten pages). He once confided his misgivings over a flirtation with organized religion, and in the process revealed his ideas about the world around him:

> It is difficult now to understand the state of mind I was in, on June 10, when I went to call on Rev. Neeb, for now it all seems so impossible that I should accept the legends of the Old Testament as facts. What was I thinking of? As I walked out thru the backyard after supper, and saw the clear sunset sky flecked with golden yellow clouds and saw the "look" on the sunlit side of the shed, I realized that for me the only divine reality is the unspeakable beauty of the world as it is.[1]

Burchfield grew up in Salem, Ohio, where his deep feeling for nature was nurtured in the woods near his home. His skills in drawing won him a scholarship to the Cleveland School of Art, which he attended from 1912 to 1916. A scholarship to the National Academy of Design took Burchfield to New York City. Although he met with some enthusiasm from dealers (his watercolors sold for $25 apiece), disenchantment with the art-school curriculum and acute homesickness brought him back to Ohio. In 1921 he moved to Buffalo to take a job as a designer with M. H. Birge and Sons, a prominent wallpaper firm. He began to paint the city's bleak industrial surroundings, and by 1929 his work had gained enough recognition, including New York gallery representation, to allow him to resign from the wallpaper company. The next year, Alfred H. Barr, Jr., organized a one-man exhibition of his work at the Museum of Modern Art, *Charles Burchfield: Early Watercolors 1916–1918*.

In *Glory of Spring (Radiant Spring)*, an acid-yellow nimbus surrounds each of two trees that dominate the composition. The critic Dave Hickey has called these lines Burchfield's "emotional cursive," a vocabulary of marks that transcribes the artist's inner state.[2] The large scale and the dense brushwork in Burchfield's watercolors impart a weight and substance not often associated with the medium.

1 Journal entry, Gardenville, July 26, 1936, in J. Benjamin Townsend, ed., *Charles Burchfield's Journals: The Poetry of Place* (Albany: State University of New York Press, 1993), 650.

2 Robert Gober and Cynthia Burlingham, *Heat Waves in a Swamp: The Paintings of Charles Burchfield* (Los Angeles: Hammer Museum, and Munich: DelMonico Books/Prestel, 2009), 41.

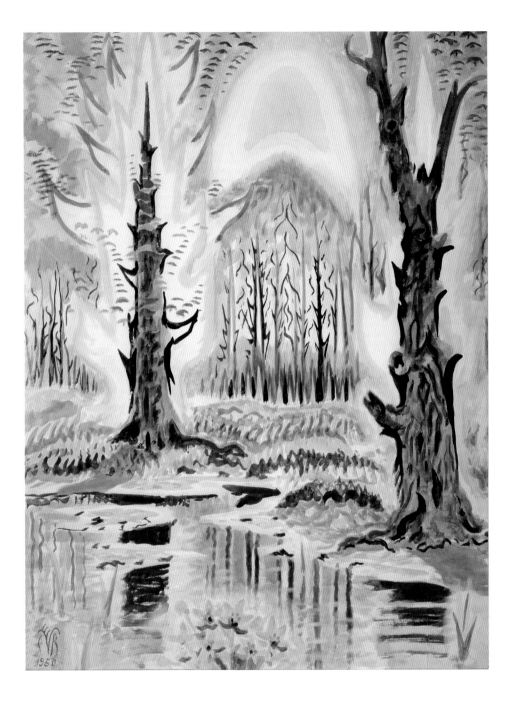

34

Glory of Spring (Radiant Spring)
1950
Watercolor on joined paper mounted on board
40 ⅛ × 29 ¾ inches
Signed lower left: CEB / 1950
Gift of Mr. and Mrs. Alfred Corning Clark, 1959.6.6

FAIRFIELD PORTER American, 1907–1975

In 1949, Fairfield Porter relocated from New York City to Southampton on Long Island, with his wife, the distinguished poet Anne Channing Porter, and their children. During summers in Maine, Porter painted out-of-doors, but in Southampton, the outside world depicted is often the one glimpsed from the interior of his studio. A stone's throw from the back door of his house on South Main Street, the studio was in an old stable, up a narrow flight of stairs to a hayloft that had been refitted with a skylight and north-facing window. Through the window and the opened hayloft doors, Porter enjoyed a panoptic view of his surroundings. For some twenty-five years, this was the primary site of his painting.

Porter greatly admired the English painter J. M. W. Turner (1775–1851) and may have been thinking of him when he wrote that "perhaps in all English painting that goes directly to nature, contour is emphasized, for contour is the last thing to disappear in a fog."[1] In *Backyard, Southampton*, Porter has kept the contours of the trees that have "disappeared" in the morning fog just beginning to be burned off by the sun.

Porter saw greater similarities than differences between his work and that of more abstract painters. In an unpublished essay from the early 1960s on Abstract Expressionism and landscape, he commented:

> Nowadays most direct expression of experience in painting takes the form of non-objectivity— these artists directly express the paint before them, their creativity and their environment, together. Some of the most direct landscape painting is non-objective. This can be said differently: some of the painting in which the experience of the environment is least translated from the total impact of nature, into paint, is non-objective.[2]

1 As quoted in Rackstraw Downes, ed., *Art in Its Own Terms: Selected Criticism 1935–1975 by Fairfield Porter* (Boston: MFA Publications, 1979), 193.

2 Ibid., 71.

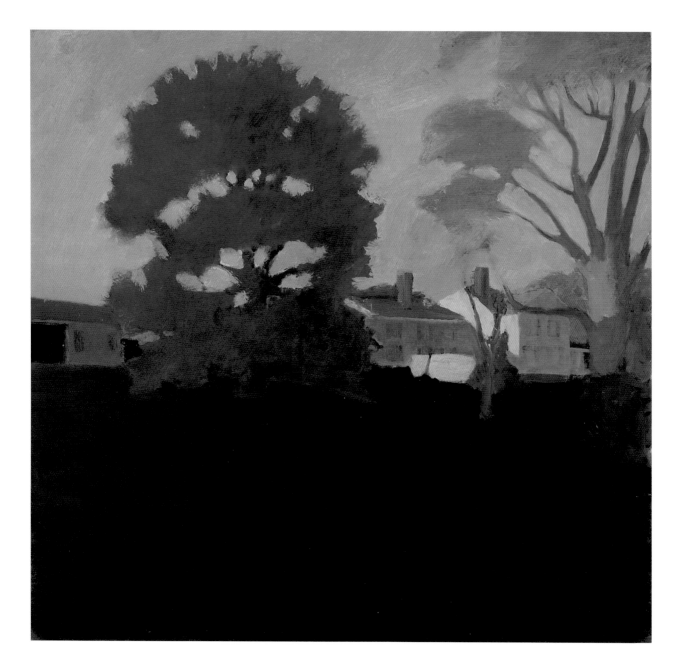

35

Backyard, Southampton
1953
Oil on canvas
42 × 43¾ inches
Signed lower right: Fairfield Porter 53
Gift of the Estate of Fairfield Porter, 1980.10.51

JANE FREILICHER American, b. 1924

In a 1960 essay for *The Nation*, Fairfield Porter reviewed the work of four contemporary artists on display in New York. Jane Freilicher's paintings, he wrote:

> describe nature. . .The subject is the outdoors, the country and the weather. There is a characteristic vertical-diagonal shear across the canvas like a visible cold front. . .Nature is not structure to [Freilicher], but rather a sensuous experience. As a whole nature is irregular and it is partly in its specific irregularity that it reveals its presence. Being tied to no place, except near the sea, the irregularity looks abstract. So beauty does not mean for her clarity and logic, but the total fact that nature is naturally specific and never the same.[1]

Freilicher was born in Brooklyn and did not consider a career in art until she was in college. Study with Hans Hofmann encouraged her to attempt the prevailing modes of Abstract Expressionism, but she soon tamped down its theatrical gesture in favor of her own personal style. In 1952, she met Fairfield Porter when he reviewed her first one-person exhibition at Tibor de Nagy Gallery in New York; they became fast friends. After visiting the Porters in Southampton, New York, she and her husband, Joe Hazan, built a house in the neighboring village of Water Mill, and a studio next door, with views overlooking Mecox Bay and the ocean beyond. Freilicher has painted what she sees from her studio hundreds of times, yet each encounter with the seen world brings fresh insight. She once confessed that she paints as she does because she has "no imagination."[2] Her wry comment masks a rigorous practice of looking, and capturing on canvas what she sees.

1 As quoted in Rackstraw Downes, ed., *Art in Its Own Terms: Selected Criticism 1935–1975 by Fairfield Porter* (Boston: MFA Publications, 1979), 90. The other artists discussed in Porter's review, titled "Kinds of Beauty," are Robert Engman, Jasper Johns, and Paul Georges.

2 Klaus Kertess, *Painting Horizons: Jane Freilicher, Albert York, April Gornik* (Southampton, New York: The Parrish Art Museum, 1989), n.p.

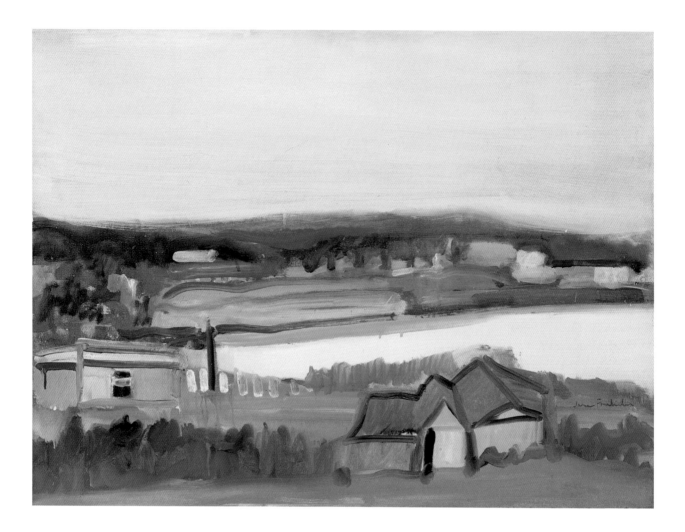

36

Grey Day
1963
Oil on canvas
24 × 32 inches
Signed lower right: Jane Freilicher
Gift of Larry Rivers, 1983.2.2

ALEX KATZ American, b. 1927

Alex Katz was born in Brooklyn and studied painting under Morris Kantor and Robert Gwathmey at the Cooper Union in New York. After graduating in 1949, he received a scholarship to the Skowhegan School of Painting and Sculpture and spent two summers in Maine. Released from the strictures of the classroom, he was struck by the freedom of being out-of-doors.

> People would go out on trucks, painting landscapes, and I had never done that, so I tried it. I found I could paint much faster, painting directly. It was the first time I had done direct painting and it was a real kick. It was a blast. It was like feeling lust for the first time...You're supposed to go where your talents are...My talents and instincts were all towards this explosive, fast, painting.[1]

Katz is an artist who has played freely with scale. Often associated with works whose dimensions are those of highway billboards, he can be just as expansive in a painting the size of *Untitled (Landscape)*. The definition of every brushstroke is evident, and reflects the rapid-fire painting that he described in his first experience of working outdoors. The brushstrokes, when considered individually, tend to dissemble the reality depicted. As Fairfield Porter observed in a 1960 review, "Alex Katz is a 'realist,' meaning that you recognize every detail in his paintings, and the whole too, though the whole takes precedence and the detail may be only an area of color, in short, abstract."[2] This tension between the "real" and the "abstract," the recognizable and the ephemeral, balances Katz's work, no matter the scale.

1 As quoted in Adam D. Weinberg, "Alex Katz: Small Paintings," in *Alex Katz: Small Paintings* (Kansas City, Missouri: Kemper Museum of Contemporary Art, 2000), 13.

2 As quoted in Rackstraw Downes, ed., *Art in Its Own Terms: Selected Criticism 1935–1975 by Fairfield Porter* (Boston: MFA Publications, 1979), 90.

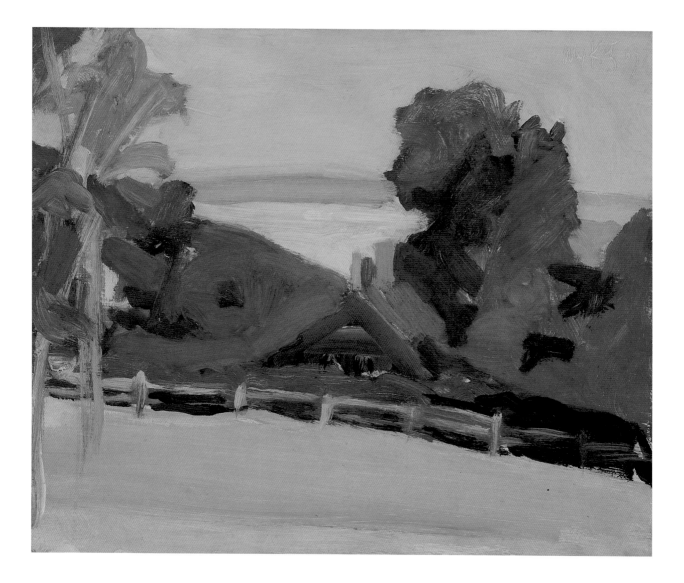

37

Untitled (Landscape)
1963
Oil on Masonite
10 × 12 ⅛ inches
Gift of Joe and Jane Hazan, 1981.15.4

FAIRFIELD PORTER American, 1907–1975

Fairfield Porter grew up in the Midwest but spent his summers since childhood at a family home in Maine on Great Spruce Head Island in Penobscot Bay. Landscape was a source of inspiration throughout his career, but Porter bristled at the term "realist" that was often applied to his work. He insisted that he painted what he saw rather than what he might assume to be there, and that whole passages in his paintings were abstract. Porter, who was also an articulate art critic, once observed: "The realist thinks he knows ahead of time what reality is, and the abstract artist what art is, but it is in its formality that realist art excels, and the best abstract art communicates an overwhelming sense of reality."[1]

Porter's passages of vigorously applied paint have an energy and authority equivalent to Abstract Expressionist handling. His admiration for Willem de Kooning was absolute. In a 1959 review of a de Kooning show at the Sidney Janis Gallery, Porter wrote:

There is that elementary principle of organization in any art that nothing gets in anything else's way, and everything is at its own limit of possibilities. . .The picture presented of released possibilities, of ordinary qualities existing at their fullest limits and acting harmoniously together—this picture is exalting. That is perhaps the general image. The paintings also remind one of nature, of autumn, say, but autumn essentially, released from the usual sentimental and adventitious load of personal and irrelevant associations.[2]

Porter's painting of a field dotted with yellow flowers and Penobscot Bay in the distance has surely shed its "load of personal. . .associations." The site may have been a favorite spot on the island he had loved since childhood, but Porter has given us much more than that.

1 As quoted in William C. Agee, *Fairfield Porter from the Permanent Collection of the Parrish Art Museum*, exhibition brochure (Southampton, New York: Parrish Art Museum, 1995), n.p.

2 Rackstraw Downes, ed., *Art in Its Own Terms: Selected Criticism 1935–1975 by Fairfield Porter* (Boston: MFA Publications, 1979), 37.

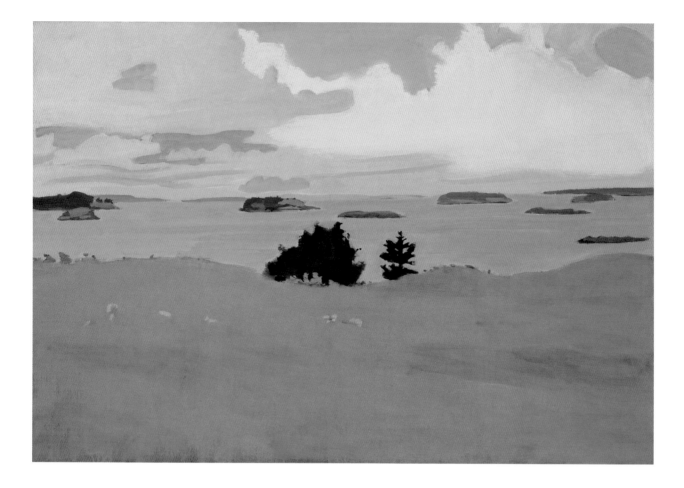

38

Penobscot Bay with Yellow Field
1968
Oil on canvas
37 ½ × 54 ½ inches
Signed lower right: Fairfield Porter
Gift of the Estate of Fairfield Porter, 1980.10.148

SHERIDAN LORD American, 1926–1994

Sheridan Lord's scene of houses and barns, defined by earth and sky, combines a specificity of locale with a universality of vision. Lord was a painter who never ventured far from home; the rolling fields seen from his front porch in the village of Sagaponack, on Long Island's East End, provided ample artistic inspiration.

Lord was born on Long Island and spent his summers since childhood in East Hampton and Amagansett. After graduating from Yale in 1950, he attended the University of Iowa Writers' Workshop and School of Art but soon withdrew from the workshop to focus on painting. After three years he left, without completing a degree, and moved to Springs, East Hampton, where he befriended the painters Jackson Pollock and Lee Krasner, who were among the few artists living year-round on the East End in the early 1950s. Throughout much of the 1960s, Lord was occupied with teaching at the Brooklyn Museum School of Art. In 1968 he bought a house in Sagaponack and the next year was living there and painting the surrounding houses, barns, and fields.

On a typical day, he would go out on foot or on his bicycle to scout locations. When he found a place that appealed to him, he would return in his car with easel and paint. By the mid-1980s, he was no longer painting at locations other than his own property. Later in the decade, he concentrated on still life—a return to an earlier enthusiasm—lamenting the loss of open vistas.

In *Landscape, Autumn 1974*, Lord painted the view from the back of his property. Neighboring farm buildings occupy the strong horizon line. A cover crop is planted in deep furrows that crisscross the canvas in dizzying perspective, converging at the painter's own house, and the pale green of the sprouting winter rye permeates the foreground. The trees along the horizon reflect the changing season, with touches of red and yellow. Lord was not an enthusiastic delineator of clouds. ("Personally I'm not really interested in clouds," he told an interviewer.[1]) His skies are more like translucent canopies of mottled color. Although he lived barely a mile from the Atlantic, he never painted there, preferring to capture the ocean's mutable atmospherics in the skies he created.

When asked whether he always tried to finish a painting outdoors, Lord responded: "There's finally a point when the canvas refers more to itself than it does to what's out there."[2]

1 John Walsh, *Things in Place: Landscapes and Still Lifes by Sheridan Lord* (Southampton, New York: The Parrish Art Museum, 1995), 38.

2 Ibid., 32.

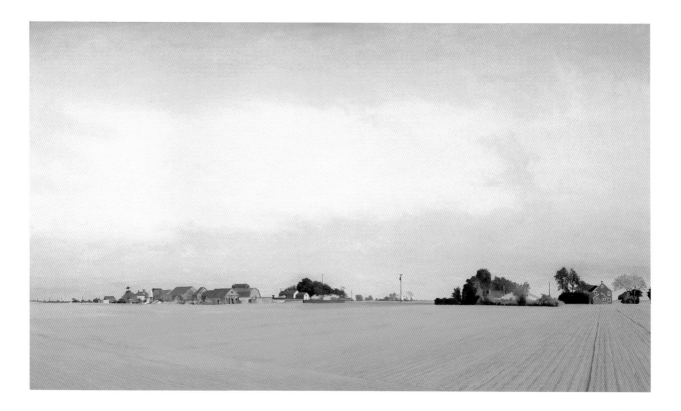

39

Landscape, Autumn 1974, 1974
Oil on canvas
40 × 70 inches
Bequest of Joseph Fox, 1996.4

APRIL GORNIK American, b. 1953

The paintings of April Gornik may have visual antecedents in the atmospheric vistas of the German Romantics and the shimmering landscapes of the American Luminists, but they do not confine themselves to looking at the past. Though not tethered to a specific time or setting, her work manages to convey an uncanny sense of place.

In *Light Before Heat*, a peninsula of green bisects the canvas laterally; the sky is mirrored in the water, effectively twinning the pink-and-blue-streaked sky. Three rocks protrude from the water. While the temptation to anthropomorphize them is strong, they remain rocks. We may intellectually perceive this as a fictive landscape, yet we are utterly convinced that these rocks, ancient as the earth, exist.

Gornik has wagered that scale plays a significant role in the way a painting affects the viewer. "I hope that when people are standing in front of the paintings they'll feel the physicality of the paintings. . .their temperature, their humidity, their air."[1] In these landscapes devoid of human presence, the viewer slips effortlessly into the universe that the artist has created.

1 *April Gornik Paintings and Drawings*, exhibition catalogue (New York: Hudson Hills Press and Neuberger Museum of Art, Purchase, New York, 2004), 40.

40

Light Before Heat
1983
Oil on canvas
66 × 132 inches
Gift of Jeanette Sarkisian Wagner, 2005.17

JENNIFER BARTLETT American, b. 1941

Jennifer Bartlett, like many young artists who grew up when Minimalism held sway, quickly adapted the rigor and seriality of that art form to her own purposes. She pursued a Minimalist route with the grid, reduced to the foot-square unit of a steel plate, but upended the process by painting directly on the gridded surface. Simple objects—a house, a tree, a boat—constitute her vocabulary. Her most famous work from the 1970s, *Rhapsody* (1975-1976) is composed of 987 foot-square plates, which fill more than 150 running feet of wall space, in a medley of themes.

Along with such process-oriented investigations, Bartlett often turns directly to nature, as in this work made at Sands Point on the North Shore of Long Island. If one is more accustomed to viewing her summative works, or seeing individual works as part of a greater whole, it is instructive to consider a single work as a complete statement. In *At Sands Point, #16*, the mark-making that defines the plate work, freed from the rigor of the grid, is transposed into brushy, impulsive strokes that define a tree and the surrounding nature in lush terms.

41

At Sands Point, #16
1985–1986
Oil on canvas
36 × 24 inches
Gift of Douglas Baxter, In Memory of Jay Rogers, 2009.13

JANE WILSON American, b. 1924

It is often said that Jane Wilson's landscape painting has been influenced by her upbringing in the flat, wide-open spaces of the Midwest, but the East End of Long Island, her part-time home since the mid-1950s, has also had a lasting effect. The proximity to the ocean and the resulting mutable weather of the region keep the air in her works alive with possibilities. "My paintings come out of my efforts to get color to embody the atmosphere we all live in, the weather that gives us life."[1]

Although Wilson is not a *plein-air* painter and literal transcription is not her objective, she fully embraces landscape as the most natural and intuitive subject matter for her.[2] In formal terms, her landscapes are characterized by a low horizon line that leaves ample room for the primary drama to occur. And for Wilson that drama consists of the ineffable permutations of our physical environment. Growing up on a farm in Iowa made her aware of the physical sensation of oncoming weather, a feel-it-in-your-bones sensitivity to her surroundings that has stayed with her. Wilson brings that intense consciousness to all she paints.

1 Elisabeth Sussman, *Jane Wilson: Horizons* (London and New York: Merrell, 2009), 120.

2 Justin Spring, "A Conversation with Jane Wilson," in *Jane Wilson: Horizons*, 47.

42

The Wave
1988
Oil on linen
77 × 100 inches
Signed lower left: Jane Wilson
Gift of Richard E. Salomon and Laura Landro, 1998.4

SELECTED BIBLIOGRAPHY

Agee, William C. *Fairfield Porter from the Collection of the Parrish Art Museum*. Exhibition brochure. Southampton, New York, 1995.

Alex Katz: Small Paintings. Kansas City, Missouri: Kemper Museum of Contemporary Art, 2000.

April Gornik: Paintings and Drawings. New York: Hudson Hills Press, 2004.

Batchen, Geoffrey. *Burning with Desire: The Conception of Photography*. Cambridge, Massachusetts: The MIT Press, 1999.

Bedell, Rebecca. *The Anatomy of Nature: Geology and American Landscape Painting, 1825–1975*. Princeton, New Jersey: Princeton University Press, 2001.

Blaugrund, Annette. *The Tenth Street Studio Building: Artist-Entrepreneurs from the Hudson River School to the American Impressionists*. Southampton, New York: Parrish Art Museum, 1997.

Broun, Elizabeth. *Albert Pinkham Ryder*. Washington and London: Smithsonian Institution Press, 1989.

Bryant, William Cullen, ed. *Picturesque America, or The Land We Live In*. New York: D. Appleton, 1872 and 1874.

Champney, Lizzie W. "The Summer Haunts of American Artists," *The Century* 30, no. 90 (October 1885).

Cooper, Susan Fenimore. "A Dissolving View," in *The Home Book of the Picturesque, or, American Scenery, Art, and Literature. Comprising a series of essays by Washington Irving et al.* Gainesville, Florida: Scholars' Facsimiles & Reprints, 1967.

Deringer, David Bernard. *Painting and Sculpture in the Collection of the National Academy of Design*. New York: Hudson Hills Press, 2004.

Downes, Rackstraw, ed. *Art in Its Own Terms: Selected Criticism 1935–1975 by Fairfield Porter*. Boston: MFA Publications, 1979.

Ferber, Linda and William H. Gerdts. *The New Path: Ruskin and the American Pre-Raphaelites*. Brooklyn: The Brooklyn Museum and Schocken Books, 1985.

Fine, Ruth E. "John Marin: An Art Fully Resolved," in Sarah Greenough, *Modern Art and America: Alfred Stieglitz and His New York Galleries*. Washington, D.C.: National Gallery of Art, 2000.

Gerdts, William H. *American Impressionism*. Seattle: The University of Washington Press and The Henry Art Gallery, 1980.

_____. *Monet's Giverny: An Impressionist Colony*. New York: Abbeville Press, 1993.

Gilpin, William. *Three Essays: on Picturesque Beauty; on Picturesque Travel; and on Sketching Landscape*, second edition. London, R. Blaimire, 1794.

Gober, Robert and Cynthia Burlingham. *Heat Waves in a Swamp: The Paintings of Charles Burchfield*. Los Angeles: Hammer Museum, and Munich: DelMonico Books/Prestel, 2009.

Goodrich, Lloyd. *Albert P. Ryder*. New York: George Braziller, 1959.

_____. *John Sloan*. New York: Whitney Museum of American Art, 1952.

Goodyear, Frank H. *Thomas Doughty, 1793–1856: An American Pioneer in Landscape Painting*. Philadelphia: Pennsylvania Academy of the Fine Arts, 1973.

Henri, Robert. *The Art Spirit*. New York: Harper & Row, 1984.

John Twachtman: Connecticut Landscapes. Exhibition catalogue. Washington, D.C.: National Gallery of Art, 1990.

Kertess, Klaus. *Painting Horizons: Jane Freilicher, Albert York, April Gornik*. Southampton, New York: Parrish Art Museum, 1989.

Kogan, Lee, *Grandma Moses: Grandmother to the Nation*. Cooperstown, New York: Fenimore Art Museum and New York State Historical Association, 2007.

Lochnan, Katherine A. *The Etchings of James McNeill Whistler*. New Haven, Connecticut: Yale University Press, 1984.

McCoubrey, John W., ed. *American Art 1700–1960: Sources and Documents*. Englewood Cliffs, New Jersey: Prentice Hall, 1965.

Maillet, Arnaud. *The Claude Glass: Use and Memory of the Black Mirror in Western Art*. Trans. by Jeff Fort. New York: Zone Books, 2004.

Merrill, Linda. *After Whistler: The Artist and His Influence on American Painting*. Atlanta: High Museum of Art, 2003.

Morand, Anne. *Thomas Moran: The Field Sketches, 1856–1923*. Norman: University of Oklahoma Press, 1966.

Novak, Barbara. *Nature and Culture: American Landscape Painting, 1825–1875*. New York: Oxford University Press, 1980.

Pilgrim, Diane. "The Revival of Pastels in Nineteenth-Century America: The Society of Painters in Pastel," *American Art Journal* 10 (November 1978).

Pisano, Ronald G. *The Artistic Discoverer of the Little Continent of Long Island*. Exhibition brochure. Stony Brook, New York: The Museums at Stony Brook, 1979.

Rainey, Sue. *Creating Picturesque America: Monument to the Natural and Cultural Landscape*. Nashville: Vanderbilt University Press, 1994.

Robinson, Theodore. "Claude Monet," *The Century*, September 1892.

Ruskin, John. *Modern Painters*. New York: John Wiley & Sons, 1885.

Schama, Simon. *Memory and Landscape*. London: HarperCollins, 1995.

Scott, David. *John Sloan*. New York: Watson-Guptill, 1975.

Shipp, Steve. *American Art Colonies, 1850–1930*. Westport, Connecticut: Greenwood Press, 1996.

Simpson, Marc, Andrea Henderson, and Sally Mills. *Expressions of Place: The Art of William Stanley Haseltine*. San Francisco: The Fine Arts Museums of San Francisco, 1992.

Sloan, John. *Gist of Art*. New York: American Artists Group, 1939.

St. John, Bruce. *John Sloan*. New York: Praeger, 1971.

Sussman, Elisabeth. *Jane Wilson: Horizons*. London and New York: Merrell, 2009.

Todd, Charles Burr. "The American Barbison" [sic], in *Lippincott's* 5, no. 22 (April 1883).

Townsend, J. Benjamin, ed. *Charles Burchfield's Journals: The Poetry of Place*. Albany: State University of New York Press, 1993.

Walsh, John. *Things in Place: Landscapes and Still Lifes by Sheridan Lord*. Southampton, New York: The Parrish Art Museum, 1995.

Whittredge, Worthington. *The Autobiography of Worthington Whittredge*. New York: Arno Press, 1969.

Wilkins, Thurman. *Thomas Moran, Artist of the Mountains*. Norman: University of Oklahoma Press, 1966.

Wilmerding, John, *American Masterpieces from the National Gallery of Art*. New York: Hudson Hills Press, 1988.

PHOTOGRAPHY CREDITS

INDEX

Page numbers in *italics* indicate illustrations.

A

Abstract Expressionism, 18, 86, 88, 92
American Impressionism, 15, 48

B

Barbizon School, 9, 11, 16, 26, 36, 52
Barr, Alfred H., Jr., 78, 84
Bartlett, Jennifer, 98
 Rhapsody, 98
 At Sands Point, #16, 98, 99
Beckwith, J. Carroll, 38, 62
Bell, Edward August, 16, *16*, 58, 64
Besnard, Paul-Albert, 15
Birch, Thomas, 11, 20
 Fishing Boats, 7, 20, 21
Boardman, William G., 40
 Untitled, 41
Brush, George de Forest, 58
Bryant, William Cullen, 13
Burchfield, Charles, 7, 17, 84
 Glory of Spring (Radiant Spring), 84, 85

C

Cézanne, Paul, 17, 70
Champney, Lizzie W., 36
Chase, William Merritt, 6, 12, 13, 38, 48,
 58, 60, 62, 76
 A Bit of Holland Meadows, 38, 39
 Shinnecock Landscape, 7, 49
Cikovsky, Nicolai, 80
 The Inlet to Wooley Pond, 80, 81
Cole, Thomas, 10, 15, 22, 24, 56
 Distant View of Niagara Falls, 15, 15
Colman, Samuel, 6, 11, 32
 Farmyard, East Hampton, 32, 33
Cooper, Susan Fenimore, 40
Corot, Jean-Baptiste-Camille, 11, 26, 52
Cos Cob art colony, 16, 66
Cottier, Daniel, 42

D

Daubigny, Charles-François, 11, 52
Doughty, Thomas, 22
 The Anglers, 11, 22, 23
 Landscape—original, 22
Durand, Asher B., 11, 22, 24, 32, 56
 Landscape, 7, 24, 25

E

East Hampton, from the Church Belfry
 engraving, 15
The Eight, 66, 74, 76

F

Fenn, Harry, 13
Flagler, Henry Morrison, 54
Freilicher, Jane, 18, 88
 Grey Day, 89

G

Gainsborough, Thomas
 Study of a man sketching holding a
 Claude glass, 10
Gérôme, Jean-Léon, 12, 50
Gilpin, William, 9, 10
 View from the Bank of a River, 10
Gist of Art (Sloan), 72
Gornik, April, 18, 96
 Light Before Heat, 7, 96, 97

H

Haseltine, William Stanley, 12, 13, 14,
 46, 56
 Anacapri, 46, 47
Hassam, Frederick Childe, 16, 60
 Church at Old Lyme, 60, 61
Heade, Martin Johnson, 14, 54
 Florida Sunset, with Palm Trees, 55
 Sunset: A Florida Marsh, 55
Henri, Robert, 6, 16, 17, 66, 72, 74, 76
 At the Place of the Three Trees, 74, 75
Henry, Edward Lamson, 6, 28
 The Old Dutch Church, Bruynswick,
 28, 29
Hofmann, Hans, 18, 88
Hudson River School, 10, 11, 24, 52

I

Ingres, Jean Auguste Dominique, 17
Inness, George, 30

J

Johnson, David, 12, 26
 Adirondack Scenery, 26, 27

K

Katz, Alex, 90
 Untitled (Landscape), 90, 91
Kensett, John Frederick, 13, 24
Krasner, Lee, 6, 94

L

Lawson, Ernest, 16, 66
 High Bridge—Early Moon, 66
 Summer Landscape, Connecticut, 66, 67
Lord, Sheridan, 18, *18*, 94
 Landscape, Autumn 1974, 94, 95
Lorrain, Claude, 9–10, 24
Luminism, 14, 18, 96

M

Manet, Édouard, 17
Marin, John, 7, 17, 70, 82
 Tunk Mountains, Maine, 82, 83
 Weehawken Sequence, 70, 71
Millet, Jean-François, 38
Minimalism, 98
Mitchill, Edith. *See* Prellwitz, Edith
 Mitchill
Modern Painters (Ruskin), 12, 56
Modernism, 7, 11, 17, 70
Monet, Claude, 13, 15, 50
Moran, Thomas, 6, 12, 34
 The Grand Canyon of the Yellowstone, 34
 Maravatio in Old Mexico, 34, 35
Moses, Grandma [Anna Mary
 Robertson], 78
 Church Among the Hills, 79
Murphy, John Francis, 14–15, 68
 Indian Summer, 68, 69

P

Peconic School, 16
Pène du Bois, Guy, 6, 16, 76
 Farm Landscape, 76, 77
Phillips, Duncan, 66
Picknell, William Lamb, 13, 30
 A French Garden, Provence, 30, 31
 La Route de Concarneau (The Road to
 Concarneau), 30
Picturesque America, or The Land We Live In
 (ed. Bryant), 13–14, 15
Pollock, Jackson, 6, 14, 18, 42, 94
Porter, Fairfield, 86, 88, 90, 92
 Backyard, Southampton, 7, 86, 87
 Penobscot Bay with Yellow Field, 92, 93
Post-Impressionism, 66
Prellwitz, Edith Mitchill, 16, *16*, 58, 64
 Entrance to Peconic, 59
Prellwitz, Henry, 16, *16*, 58, 64
 Frozen Creek, 65

R

Realism, 66, 92
Richards, William Trost, 11, 12, 56
 Untitled (Seascape), 57
Robertson, Anna Mary. *See* Moses,
 Grandma
Robinson, Theodore, 13, 50
 Moonlight, Giverny, 50, 51
Rodin, Auguste, 17
Rousseau, Théodore, 26
Ruskin, John, 12, 24, 26, 46, 56
 Fragment of the Alps, 12, 13
 Modern Painters, 12, 56
Ryder, Albert Pinkham, 11, 14, 17, 42
 The Monastery, 43

S

Shinnecock Hills Summer School, 6,
 16, 48, 74
Sloan, John, 16, 17, 66, 72, 76
 Gist of Art, 72
 Hill, Main Street, Gloucester, 72, 73
Smillie, George Henry, 11, 14, 36
 Farm, Long Island, 36, 37
Steichen, Edward, 70
Stieglitz, Alfred, 17, 70

T

"The Ten," 15
Tonalism, 11
Turner, J. M. W., 12, 86
Twachtman, John Henry, 15, 16, 52, 60,
 64, 66
 Horseshoe Falls, Niagara, 8, 15, 52, 53

V

Van Gogh, Vincent, 17

W

Weir, J. Alden, 15, 60, 64, 66
Whistler, James Abbott McNeill, 38, 44
 Blue and Silver, 44, 45
 Nocturnes, 44
Whittredge, T. Worthington, 13, 46
Wiles, Irving Ramsey, 16, *16*, 58, 62, 64
 Scallop Boats, Peconic, 62, 63
Wilson, Jane, 100
 The Wave, 7, 101
Wylie, Robert, 30